INDIAN
ARTISTS
at WORK

Ulli Steltzer

Foreword by Doreen Jensen

Douglas & McIntyre

Vancouver/Toronto

For all of you who let me visit,
and for my mother

My deeply felt gratitude to Doreen Jensen, who introduced me to many of
the artists in this book. A fine carver herself, she opened my eyes to the
intricacies of the different artforms.

My special thanks to Margaret and Tom Blom for their encouragement
and their patient help with the manuscript, and to the Canada Council
for the Explorations grant which helped me to finish this work.

Copyright © 1976 by Ulli Steltzer
Foreword © 1994 by Doreen Jensen
94 95 96 97 98 5 4 3 2 1

Third paperbound edition, 1994

Douglas & McIntyre, 1615 Venables Street, Vancouver, British Columbia V5L 2H1

Canadian Cataloguing in Publication Data
Steltzer, Ulli, 1923-
Indian artists at work

ISBN 1-55054-147-1
1. Indians of North America—British Columbia—Art 2. Indians of North America—Portraits
3. Indians of North America—British Columbia I. Title
E78.B9S75 1994 704'.03970711 C94-910090-0

Design and production co-ordination by Mike Yazzolino
Cover design by George Vaitkunas
Cover photograph of Mabel Taylor weaving a basket
Typesetting by Domino-Link Word and Data Processing Ltd.
Printed and bound in Hong Kong by Colorcraft Ltd.

CONTENTS

FOREWORD

Ulli Steltzer came to me in the early 1970s with her idea for producing a photographic journal of Indian artists at work in British Columbia and said she would need someone to introduce her to the artists. I was intrigued by her project. Throughout my life, I had been involved in the Gitksan nation's cultural reclamation. When I moved to Vancouver in 1972, I broadened my knowledge of other First Nations art. I worked for Kilsli, an arts and crafts store owned and operated by the Indian Homemakers of B.C., and then for Central Marketing Service, a federal government corporation set up to develop and expand the market for First Nations art. In that job I travelled across the province, meeting First Nations artists and buying the best of their work.

I realized there were few books at that time heralding First Nations artists and their works. Few books said, "Yes, they are still here. Their art and culture are flourishing. Yes, they are creating history. They are passing on important knowledge." I immediately told Ulli I would love to introduce her to some Indian artists. So we travelled to Vancouver Island, Mount Currie, Haida Gwaii (the Queen Charlotte Islands) and my home territory, the Hazelton area, to meet the 'Ksan artists. It was an exciting time for me, travelling with someone who was as excited about the people and their work.

When *Indian Artists at Work* was published, it served as a small window through which you could glimpse the lives of the traditional artists of these lands, the historians, visionaries and teachers. Through the lens of Ulli's camera, you see the spirit of a people who have worked in obscurity, even while the objects they created with such genius were eagerly documented by scholars and sought by collectors.

Behind each of Ulli's photographs, there is a person with many stories. The late Mabel Taylor was a woman who endured many changes. When Ulli and I visited her, we had to cross railway tracks and the yard of a plywood mill, dodging front-end loaders and trucks, to find the small dirt road that led to her home by the Alberni Canal. There she was, sitting by the window, weaving beauty and philosophy in her sea-grass basketry.

Simon Charlie worked in a huge studio that reminded me of a long house. Every square inch was full of materials for his art, works in progress, and completed sculptures that ranged from the monumental to exquisite miniatures. He also had a display of works by his many apprentices. Simon showed us masks that would never be seen except in long house ceremonies. He also showed us a sweater he had designed and knit! Today you can see one of his welcome figures at the Royal British Columbia Museum in Victoria.

Bill Reid's *Raven Discovering Mankind in a Clamshell* was the maquette for his big sculpture at the University of British Columbia Museum of Anthropology.

Sarah Modeste, an entrepreneur extraordinaire, is committed to her business of making wool and knitting it into sweaters, tuques and mitts. Everywhere in her house, there was wool, wool, wool. Even though her husband, Fred, is allergic to it, he supports her business wholeheartedly. He has since constructed a huge building to house both the wool-making business and a storefront. Sarah supplies most of the wool for the Cowichan knitters and also markets the products to retailers across North America and as far away as Japan. Her customers include Ralph Lauren's Polo line.

The late Alice Paul told me she used only female sea-grass for her baskets. "How do you tell which is female and which is male?" I asked. With a twinkle in her eye, Alice said, "The male grass has a hard centre spike." She also told me, "The grass grows with lumps, not smooth like it used to be, because of the pollution."

I have always held the women who weave their histories in their baskets in the highest esteem. The baskets combine geometry and algebra with a balance of colour and form while telling, visually, the history of a people. I am amazed by the women's sense of space and place, as well as their understanding of the natural materials they work with. *Luu sa nahl asxw goodii.* My heart is in awe.

From 1884, it was against the law for First Nations people to participate in the ceremonies which comprise our art, law, education, philosophy and government. My people could not make ceremonial robes, masks, totem poles, house posts and feast dishes. It wasn't until 1951 that the "potlatch ban" was rescinded and it became possible to openly practise our culture and create our art again. The art had never died. We knew how to make art even though in some cases all we had to go on were the legends and histories that our families told us; the oral history was so clear we could see pictures as they spoke. Such legends inspire artists like my brother Walter Harris, who is in this book. People marvel at masks such as his *Salmon in Human Form*, which came into being from his knowledge of Gitksan history.

Starting in the 1940s, some people curated exhibits of both historic works and those by contemporary First Nations artists. The 1970s, when Ulli took these photographs, were a time of change, empowerment and collaboration. There was collaboration between Ulli and her subjects, and between First Nations communities and non-native culture. That was when I, along with other First Nations artists, formed the Northwest Coast Indian Artists' Guild with the support of Don Steele of the Royal Bank and Bud Mintz of Langara College.

In 1976, the University of British Columbia Museum of Anthropology opened. Dr. Michael Ames, now its director, says that when the totem

poles were being moved out of the storage sheds and into the great hall, a raven followed them in, cawing. It was a pivotal time; he and others stopped thinking of museums as places to house relics of dying cultures and began to understand them as places which could celebrate the continuity of living cultures and their traditional arts.

Much has changed, and much has yet to change. We continue to witness the struggle over land claims, and protests over land issues have escalated. These events are being recorded by First Nations artists. We continue to evolve, explore and enjoy new materials and media, though our philosophy always remains close to the roots which nourish it. Some continue to speak through traditional forms, like Robert Davidson, Walter Harris, Joe David, Freda Diesing and myself. Others work with new technologies: Loretta Todd makes documentary films; many new artists are working with video. Sharon Hitchcock, Lawrence Paul, David Neel, Francis Dick, Marion Nicholson and others are combining traditional forms and new media to create exciting, challenging art. We are not vanishing.

Sadly, many of the artists pictured in this book have died. One of these is Chief James Sewide, who said, "Our history was not in books—but it was carved into poles, masks, and talking sticks; put on blankets and passed on to us as honour and authority." I acknowledge our teachers who are no longer here, and the wisdom they have passed on to us. As Gloria George said at a conference in 1993, "See those empty chairs? They are not empty. Our ancestors are there."

Ulli's photographs help us to explore our differences and our commonalities. Like all artists, she looks into the soul of her subjects. In these intense and gentle pictures, she shares their greatness with you. The artists in this book have something vitally important to offer: a new—or ancient—aesthetic, a way of understanding art and the world that can help us all to find a place in it.

—Doreen Jensen

INTRODUCTION

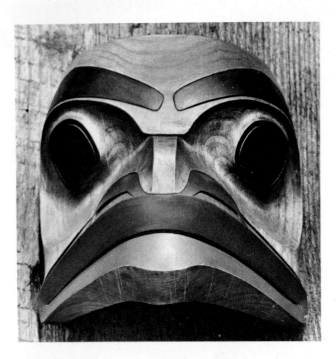

When I walked into Robert Davidson's studio, he was sitting surrounded by wood chips, carving a Frog mask. "I saw a frog when I was up in Masset and it sure turned me on. I also saw a killer whale. It came up three times. It was beautiful. I got a real good look at it." The chips kept on flying. "To see that killer whale was quite inspiring. So often I carve things and never see the animal; seeing it was important to me. It helps me in my designing. After I see the animal, I get a different feeling for it. The whole art is based on subtleness. The Frog mask certainly does not look like a real frog but there are certain characteristics that remind me of a frog. Basically, what I am doing is trying to please myself."

Robert Davidson's words express the excitement and wonder I felt during the year I spent photographing Indian artists of British Columbia. Their words and my pictures together form a kind of photographic diary, my personal response to these artists' love for their work. It was a beautiful year, full of discovery. I love the smell of sheep wool, of cedar, and of smoked hides now. I love the feel of smoothly polished argillite and the soft surface of a wooden mask or bowl.

This book came about partly because of the contrast that struck me when I moved to British Columbia after having spent some time photographing Indian people of the American Southwest. Unlike the dry and barren land of New Mexico and Arizona, with its adobe houses only distinguishable from their surroundings by the deep shadows they cast, the Northwest is blessed with plentiful rain and lush forests, with lakes and rivers, fish and birds and game. For generations, the abundance of this land benefitted the Indians.

The old people told me about "long ago": the big houses they used to have where large families lived together; their elaborate feasts and potlatches when a whale was caught. They told me about carved posts and poles, bowls and spoons and the carved Welcome Man and Woman. And as they talked, their personal memories often intertwined with legends about rocks and animals who were people long ago.

They also told about the time when the white man came. In Ahousat, on the west coast of Vancouver Island, they still call him "mau mau'l ney," which means "floating on the water without land." They told me about the many people dying from tuberculosis and other new diseases, and about the time when their potlatches were outlawed. They talked about secret ceremonies in the Duncan area and secret potlatches among the Kwagutl people. No poles could be raised in those years.

Because their carving had been of a ceremonial nature, carving stopped altogether when ceremonial life was so persistently suppressed—although among the Haida and Kwagutl people and to some extent among the Vancouver Island west coast people, some carvers carried on the tradition. While basket weaving and the work with hides were never interrupted, the Salish weaving which depended on mountain goat wool and a special kind of dog hair was totally discontinued. Today it is hard to imagine that fifteen years ago very few people were carving and that the art of Salish weaving was almost forgotten. Since then, through individual and organized efforts, the traditional crafts have been revived. An ever-growing number of men and women of all ages are devoting themselves to creating objects which show the vitality of their heritage. These people speak for themselves in the following pages.

Traditional crafts require special tools that are not available in stores and have to be made by the people. One woman scrapes her hides with rocks attached to wooden shafts. Instead of rocks, another uses pieces of iron, and wrings her hides on the huge sprucewood frame her husband made for her. Deerbone awls are still the standard tool for weaving cedar root baskets. The Cowichan knitters and the "Salish Weavers" often turn an old sewing machine into a spinner, or attach an old washing machine motor to a carder. Carvers make differently shaped knives and adzes in all sizes and often decorate the handles of their favorite tools with beautiful carvings. But when a power tool can do the rough cutting, it may be used as well. And when a tourist said to one of the 'Ksan carvers who was using a chain saw to cut a log, "Your grandfather didn't use that, did he?" the answer came back firmly, "But he would if he'd had one." Later this incident became a source for endless joking among the carvers: "How did you get here?" "By car." "How come you didn't walk like your grandpa did?"

The artists depend upon the land for most of the materials of their arts and crafts. Red cedar grows everywhere along the coast, as well as in the coastal valleys and mountains. Argillite, a soft slate used for carving,

occurs in the Queen Charlotte Islands. And here also, spruce roots and cedar bark are woven into hats. The Vancouver Island west coast baskets are woven of various grasses growing on and near that part of the coast, and the women along the southeast coast of Vancouver Island and in the Fraser Valley knit and weave the wool of local sheep. Up north in the lakes district, where the winters are cold, moose and deer provide hides for clothing, and baskets are made of spruce root and the local birch. Wherever I went, I found these materials being handled and stored like treasures.

I knew little of all this when I began traveling and photographing. I had to learn that the gathering of roots and grass and barks is seasonal. "You have to come back when the sap is rising... when it gets warmer... when the snow is off the mountains... when the daisies are blooming... when the river goes down... when the grass is long enough." Lucky for me that the sap does not rise in the Queen Charlotte Islands when it rises in the Fraser Valley.

My appreciation for baskets grew as I watched the backbreaking labor of a woman pulling the cedar roots out of the root-matted ground. She wanted straight, thick, long roots, which are hard to find among the heavy underbrush in the logged areas. Again and again I was impressed with the complexity of the various processes and with the patience and care with which the women followed the seasons of the year, collecting and preparing these materials. The experience and observation of generations is woven into each single basket and brought alive through individual expression and imagination.

The very generous help and co-operation of the Indian people themselves made this book possible. They guided me on my travels through British Columbia and gave me introductions to their fellow artists, who not only allowed me to photograph them and talk to them about their work, but also often invited me to live with them while I was working in their area. I delighted in these long visits: they allowed for long talks and often for story-telling time. I carefully collected the information gathered in my travels and have used it as the sole source for the text in this book, and I have used the spelling of Indian words that the artists and my Indian friends have preferred.

In many ways, my book is incomplete. I regret I could not meet and photograph every artist, and I could not fully represent the work of those I met. But I hope these pages will serve to introduce the Indian artists of British Columbia. Again and again, they told me, "The only way to do a good job is to enjoy what you are doing." I deeply enjoyed what I was doing, and I hope this book honours the people to whom I dedicate it.

Vancouver, British Columbia
June, 1976.

HAIDA CARVERS

Queen Charlotte Islands

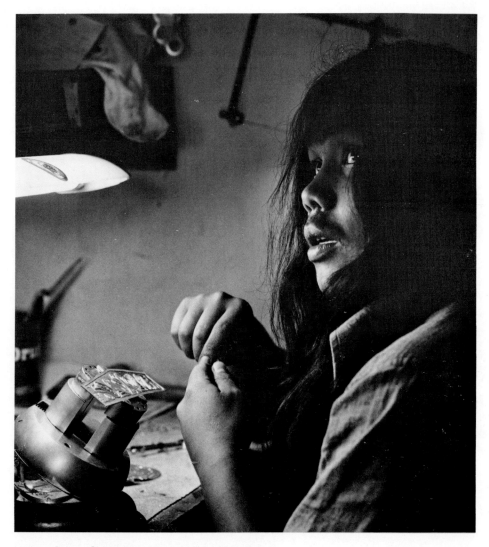

Nelson Cross, Skidegate, carving silver bracelet

"You have to feel it before you can do it, not just like a job."

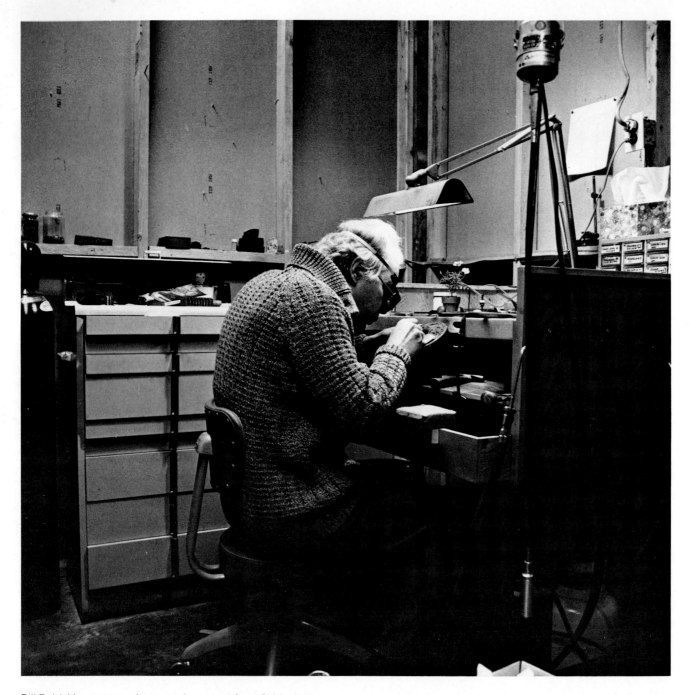

Bill Reid, Vancouver, whose mother came from Skidegate

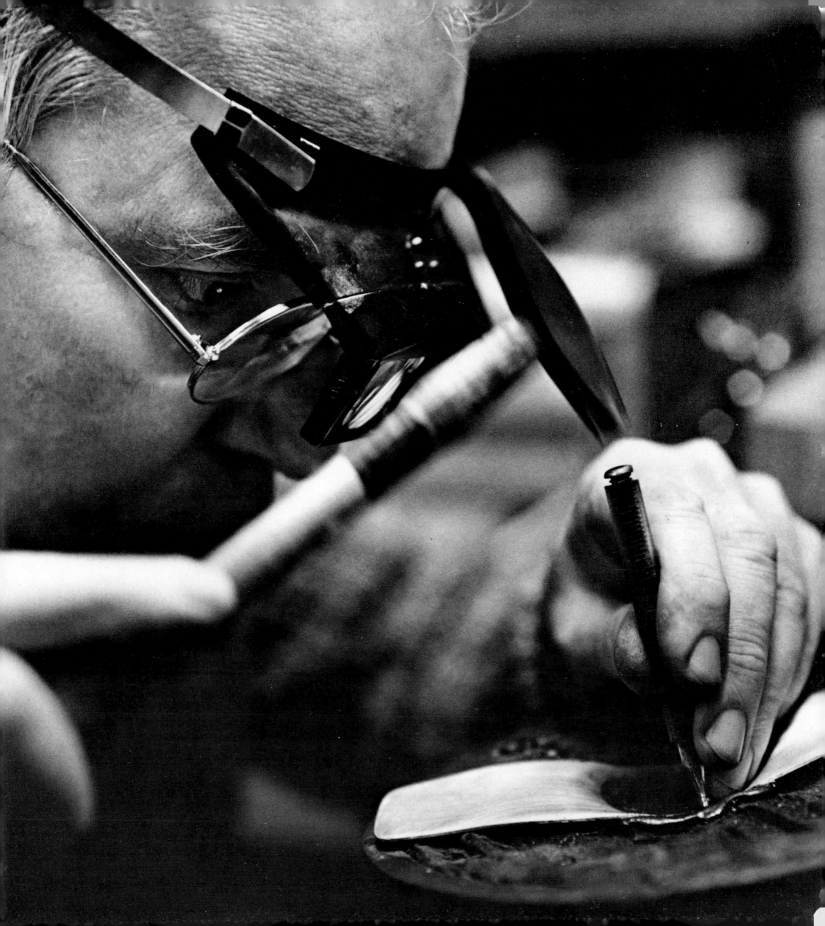

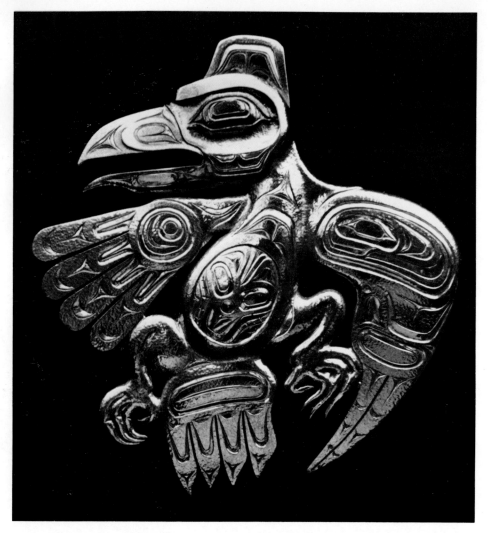

Raven brooch, gold, by Bill Reid

"Raven is the deus ex machina, the most important figure in Haida mythology. There are many Raven myths. He is the one that caused everything to happen, though quite inadvertently. He was, for instance, the one to steal the sun, but it was the Eagle who put it up in the sky so there would be light in the world. The Haidas are divided into Raven and Eagle moieties. All the other crests, like the Bear, Beaver, Killer Whale, are minor crests."

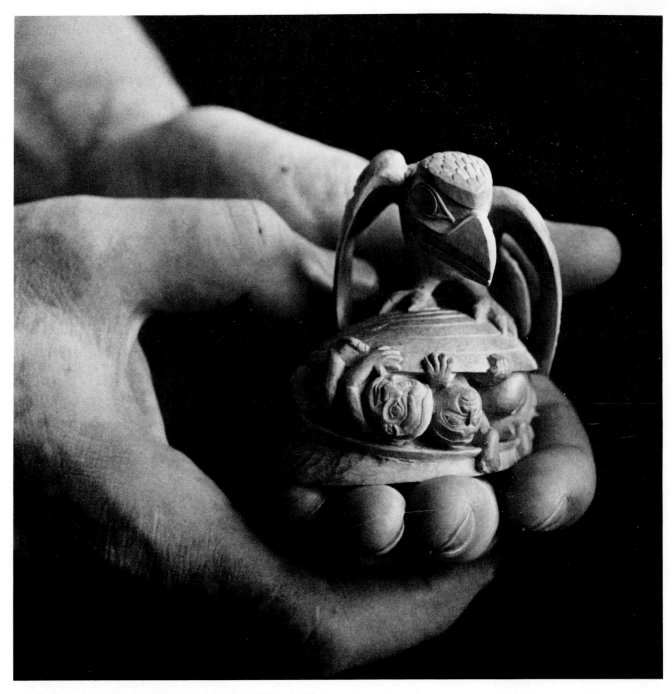

Raven Discovering Mankind in the Clam Shell (Haida myth),
boxwood carving by Bill Reid

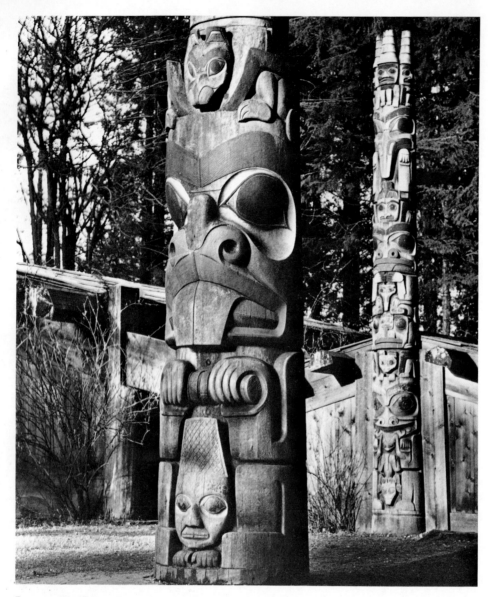

Beaver pole, Totem Park, University of British Columbia, by
Bill Reid

"I used the Beaver because he is a nice fellow. There are quite a
few Beaver poles around. The Beaver seems to have been quite
a prominent crest. The old Beaver pole from Tanu is certainly
one of the nicest poles there is, and the last pole in Skidegate is
a Beaver pole, so it seemed to be quite logical to carve one. The
upward thrust of the design, the form of the Beaver, seems to
integrate well with that type of pole."

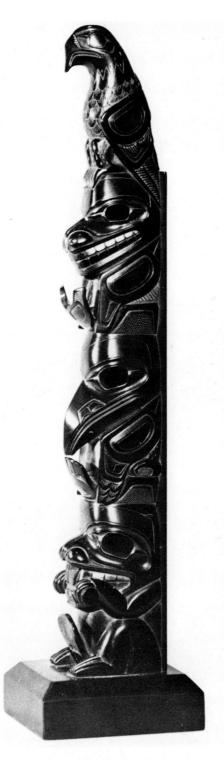

Pat Dixon, Skidegate, designing a pendant

Detail of Pat Dixon's Beaver pole

Argillite pole by Pat Dixon: Beaver, Raven, Killer Whale, and Eagle

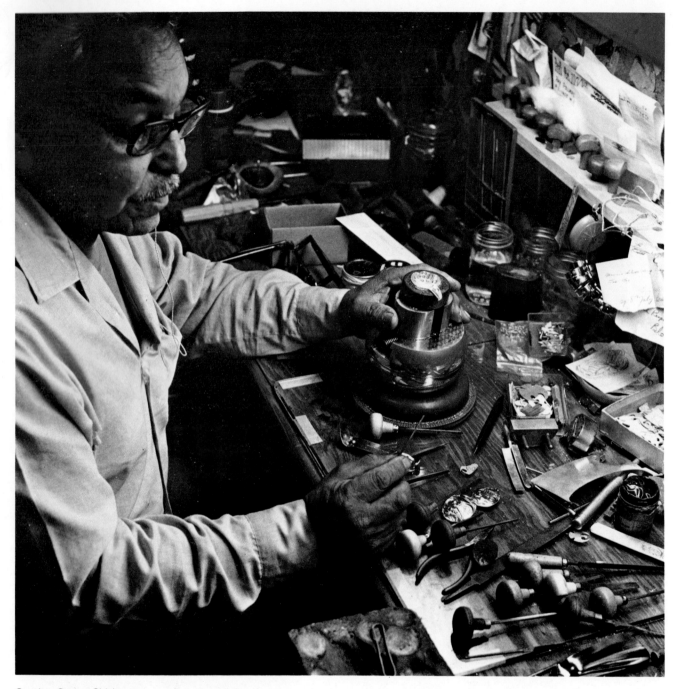

Gordon Cross, Skidegate

"I was a fisherman for forty years, but I had an accident in 1965 and started silver carving. It was very successful from the beginning. I can't keep up with my orders."

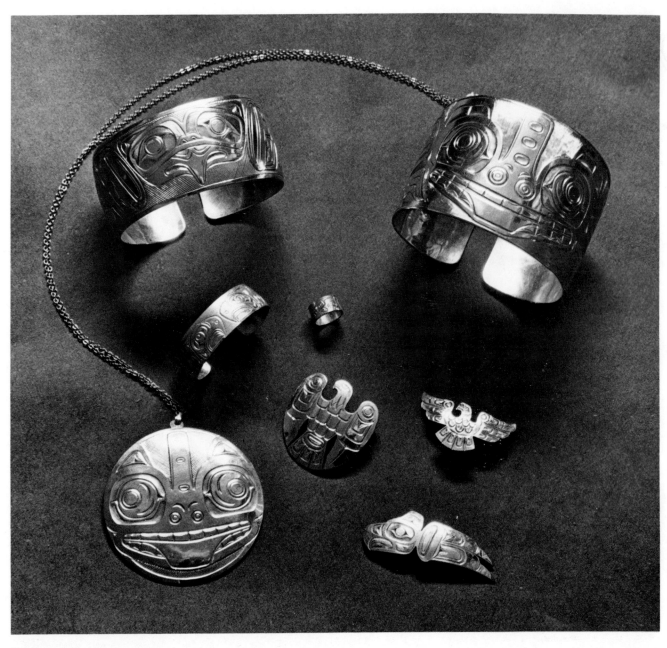

Gold jewelry by Gordon Cross
All these pieces were made by the artist for his family over a
period of eight years.

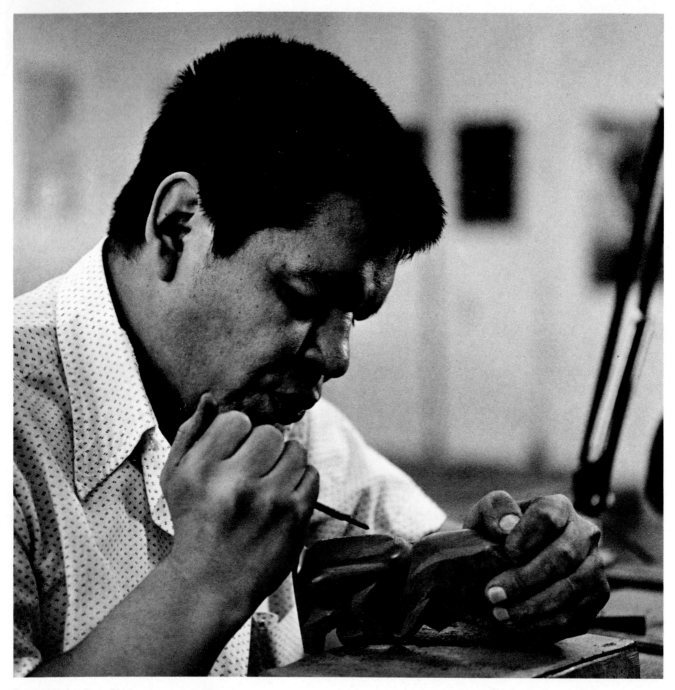

Doug Wilson, from Skidegate, now in Victoria

"The Queen Charlotte argillite is unique in its carveable quality. We call it argillite or slate, either way. I can express myself better in it than in any other material."

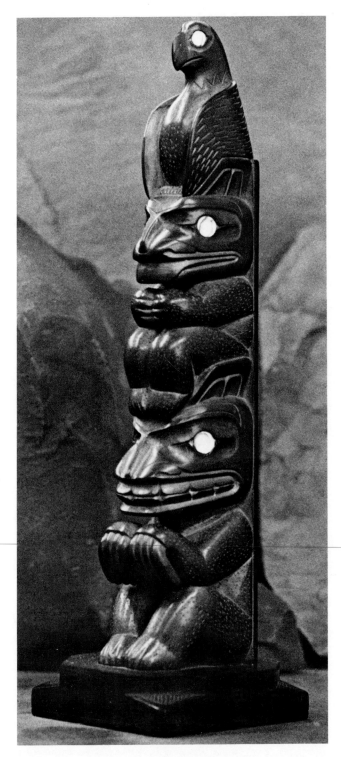

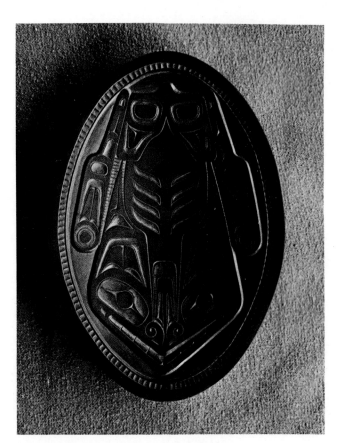

Killer Whale bowl, argillite, by Doug Wilson

Two Bears and Eagle, argillite with abalone inlay,
by Doug Wilson

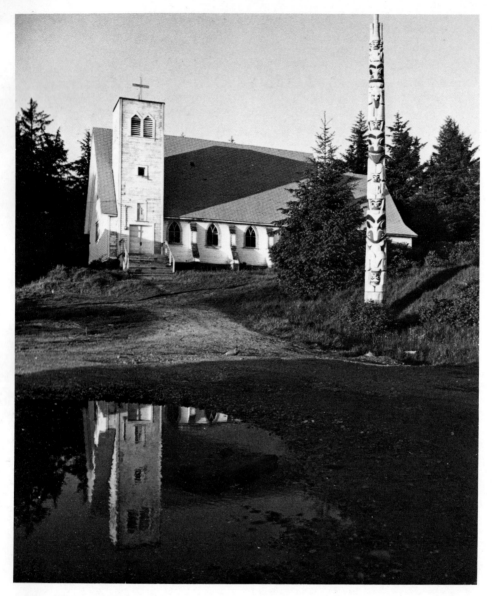

Anglican Church in Masset with Robert Davidson's Bear
Mother pole, raised in 1969

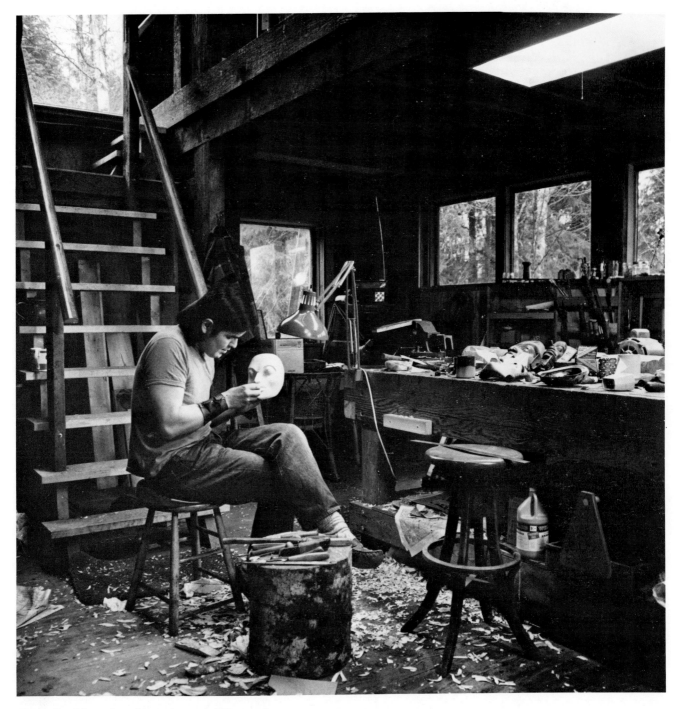

Robert Davidson, from Masset, now in Whonnock

"I like to believe in a balance. I am taking from the art and I like to think that I am giving to it."

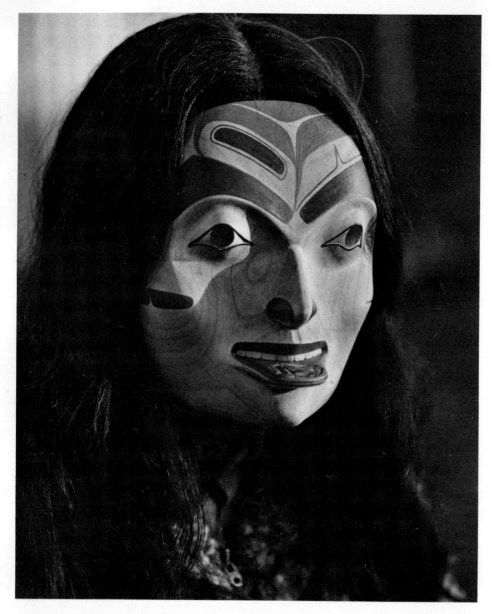

Mask, Woman with Labret, alder wood with abalone inlay,
by Robert Davidson

"The labret was a sign of prestige; only women of high ranking
families used to wear it. A small piece of stone or wood or bone
was inserted into the lip of a little girl and replaced with larger
pieces as she grew older."

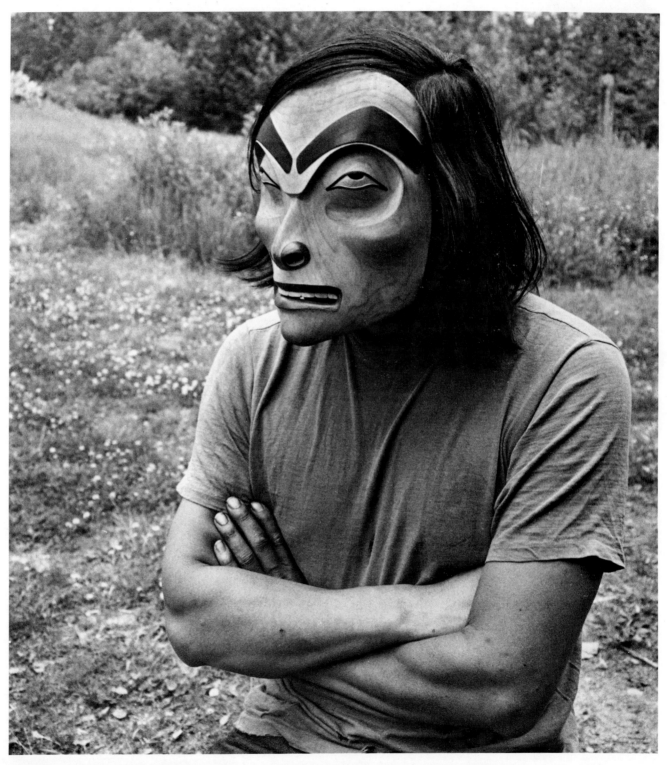

Dead Man's Mask, alder, by Robert Davidson

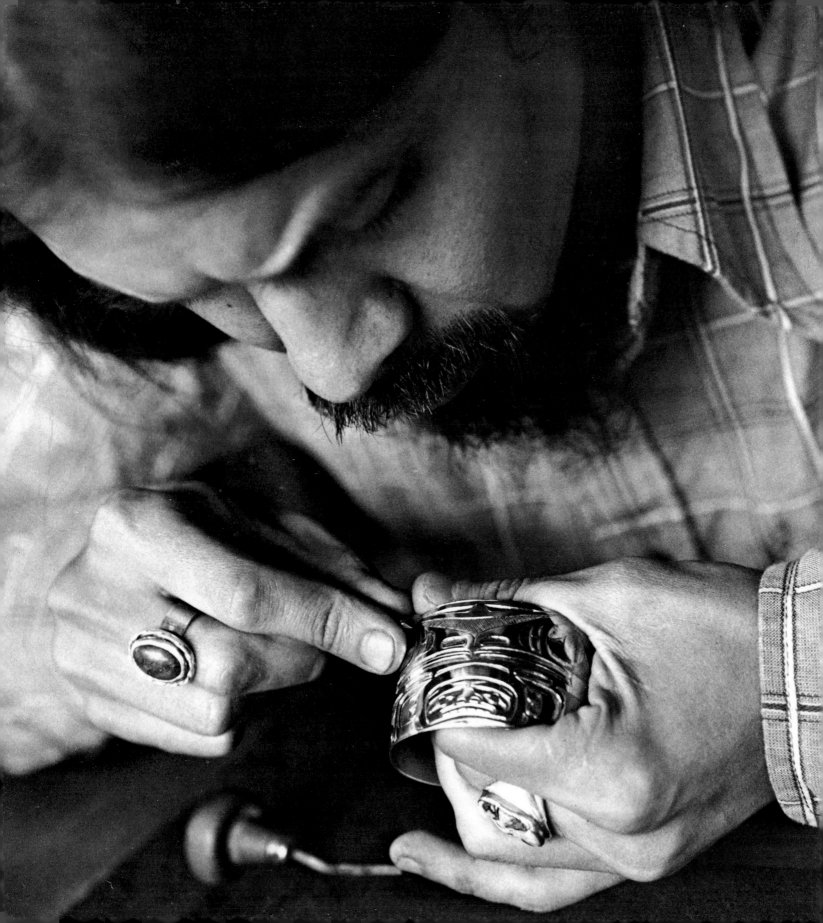

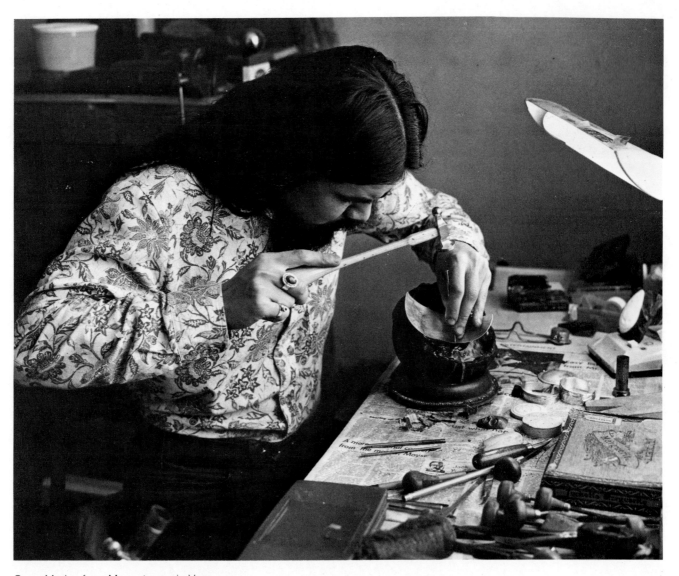

Gerry Marks, from Masset, now in Vancouver

"Repoussé I find one of the more challenging techniques. We use silver now and gold; long ago my people used copper to make shields and bracelets. They used to trade with it.
I spend a lot of time making my tools, and really treasure them. We get the metal for the gravers either from files, commercial gravers, or drill rod, but we still have to shape them to our own hands and to each particular job. This applies also to the engraving of argillite and to wood carving. Yes, tools are pretty important, you wouldn't get far without them."

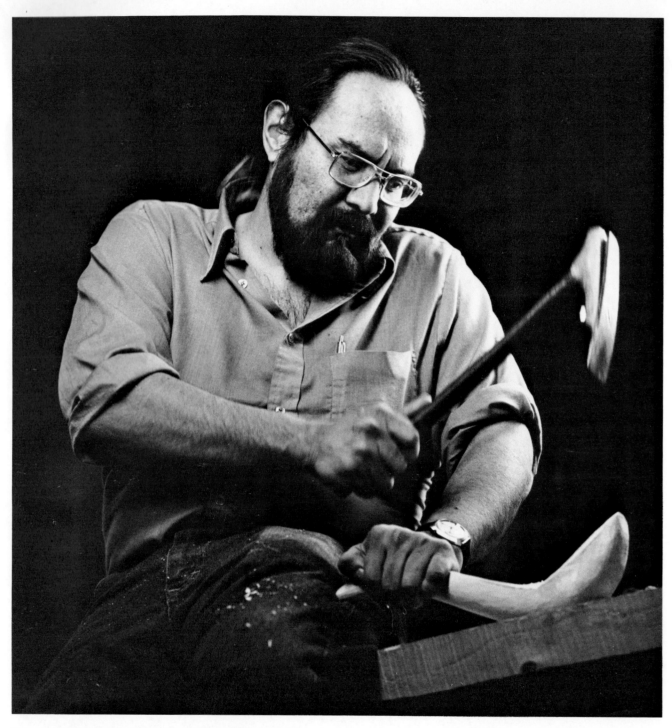

Francis Williams of Masset, now in Victoria. Well known for
his silver jewelry, he works here with wood for a
change—adzing out a spoon.

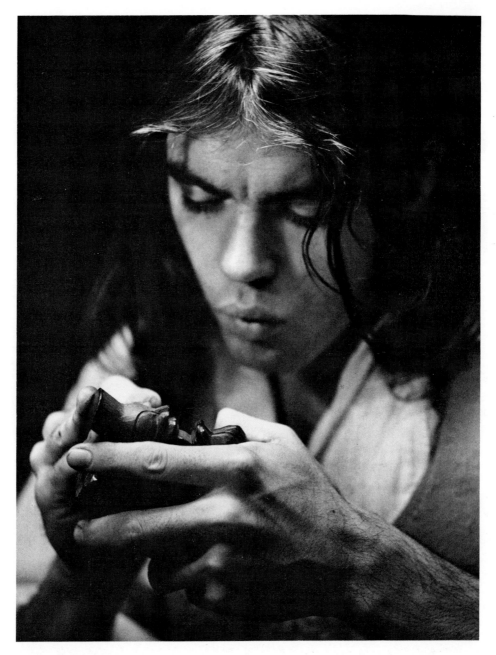

Greg Lightbown, Masset

"My teachers are the shadow and the light—and, of course, all
the other carvers, and the ones who lived before."

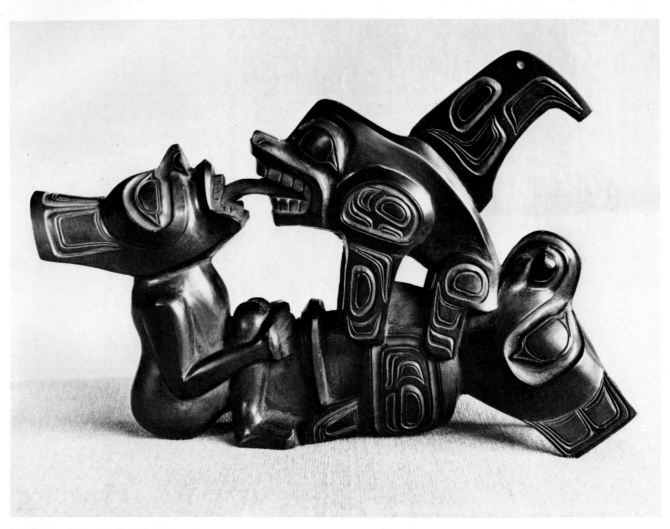

Argillite sculpture by Greg Lightbown

"It is the story about the boy who was to find out what made the thunder. In the sculpture he is becoming a carver by receiving the Spirit from the Whale while the Thunderbird is holding the Whale in his mouth."

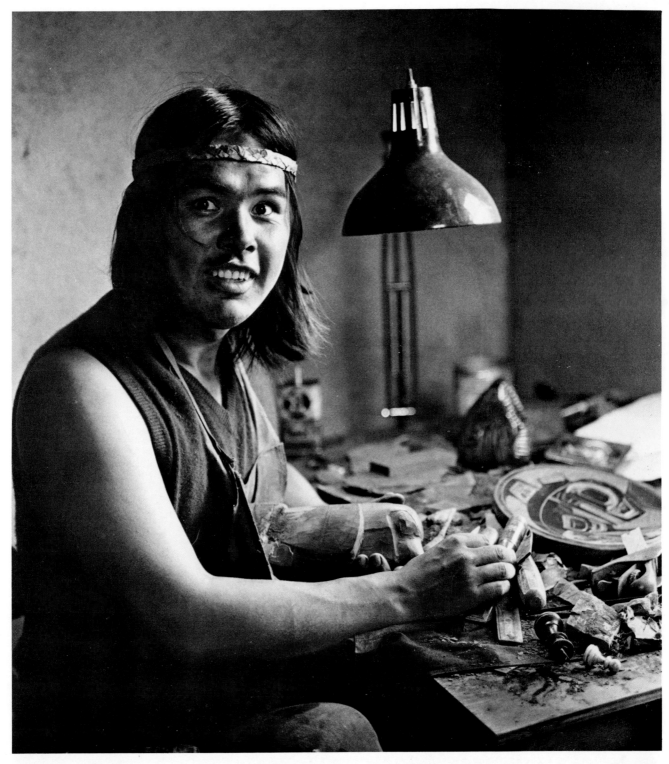

Reg Davidson, Masset

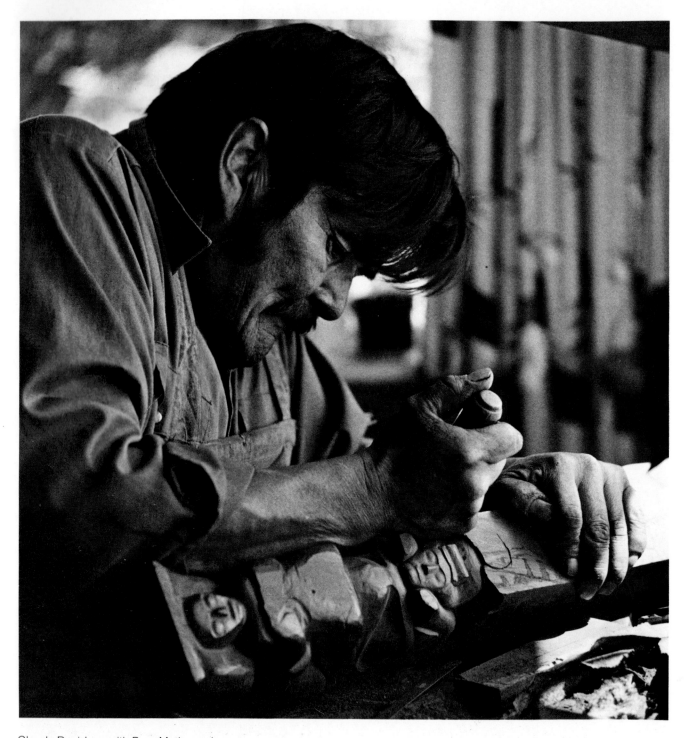

Claude Davidson with Bear Mother pole

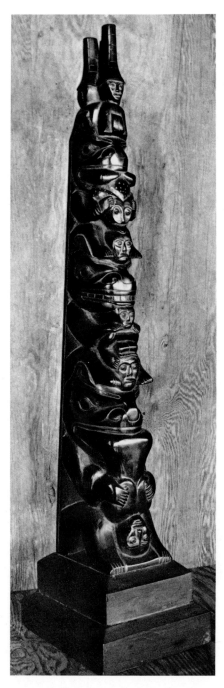

Bear Mother pole by Claude Davidson

"I sure hate to let my carvings go. It doesn't feel right. I put my whole soul into them, and then what do I have? Just a piece of paper."

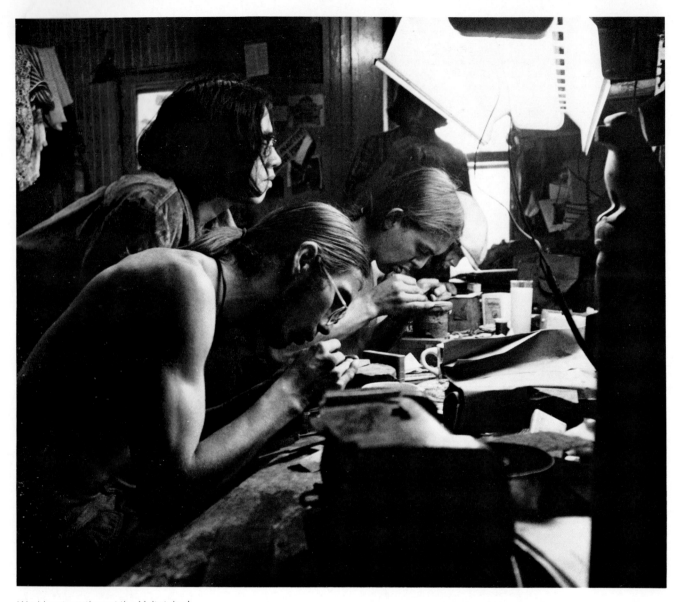

Working together at the Yeltatzies'

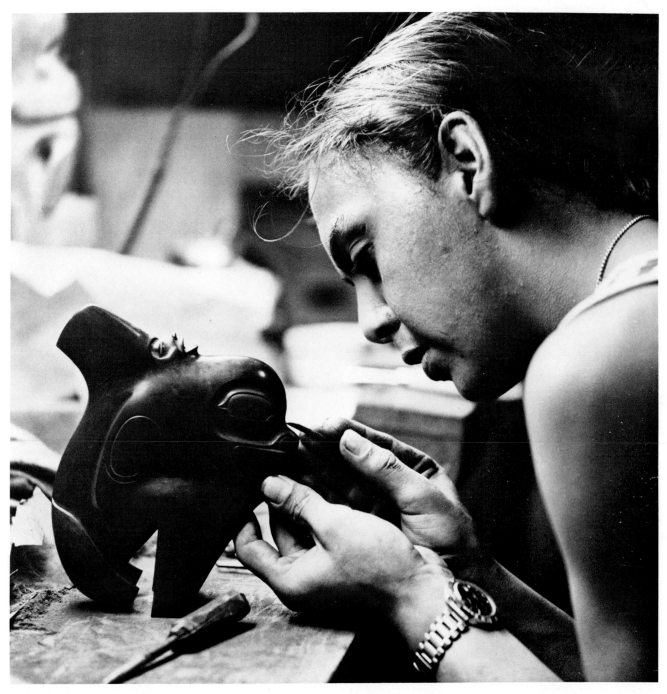

Fred Davis, Masset

"It is a man changing into a killer whale; the fins of the whale
are also the hands of the man."

John Yeltatzie, Masset, sawing the argillite

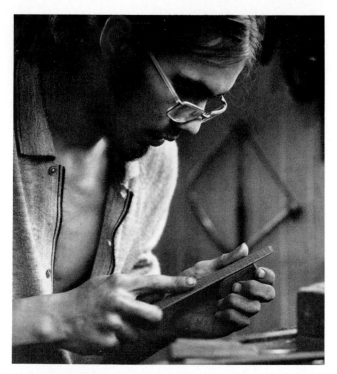

Filing it into shape

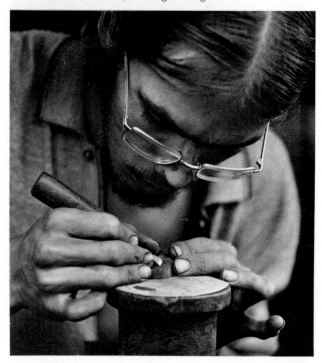

Engraving the design

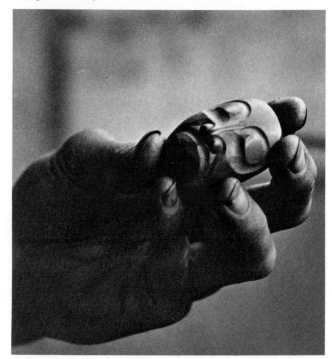

Inspecting it half way

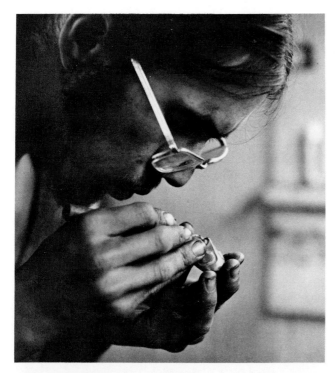

Final engraving

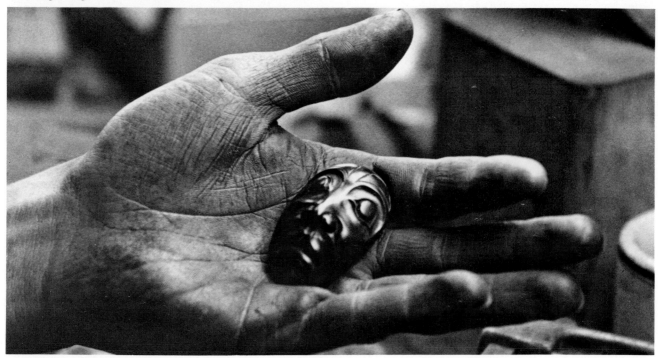

The finished piece

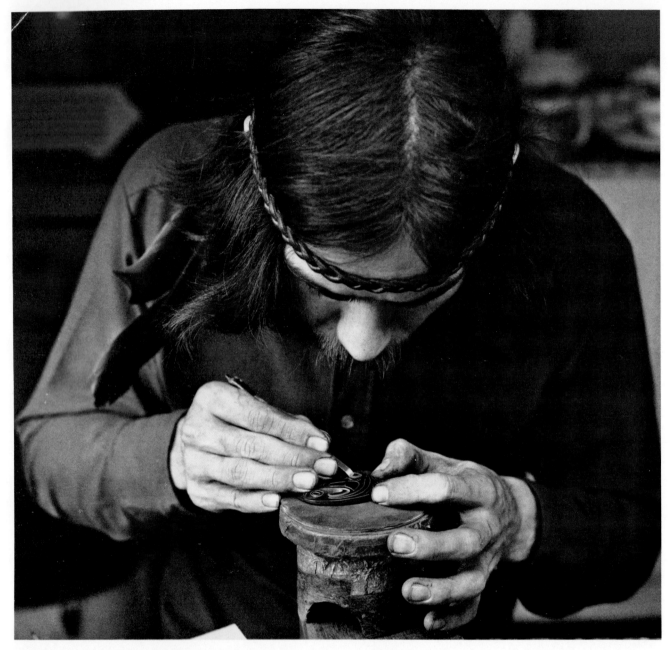

George Yeltatzie, Masset, working on argillite pendant

"If a person understands your art, they understand you. There is often a long time of contemplation before starting a new piece."

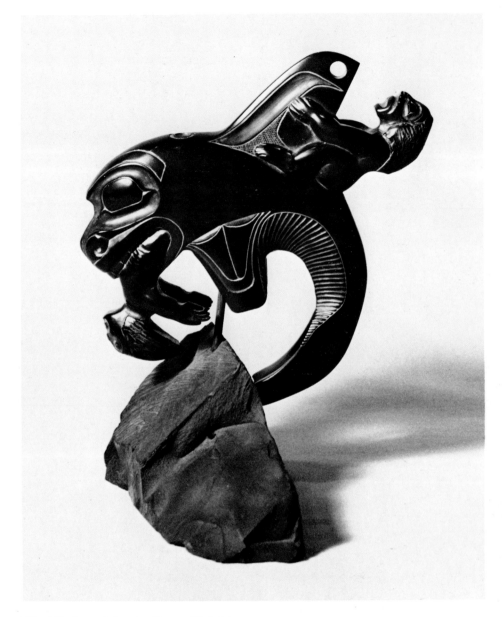

Killer Whale sculpture by George Yeltatzie

"The Killer Whale is kidnapping the woman. The man on its back is trying to retrieve his wife."

HAIDA
BASKET WEAVERS

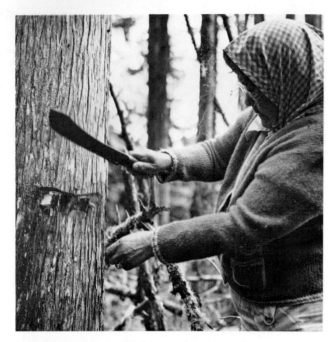

Florence Davidson, Masset, cutting cedar bark
to weave a hat

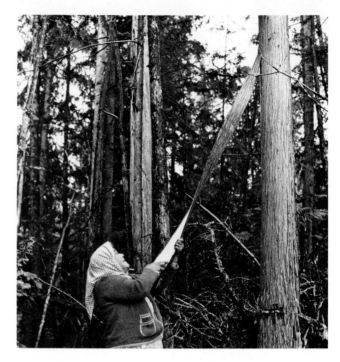

Pulling cedar bark

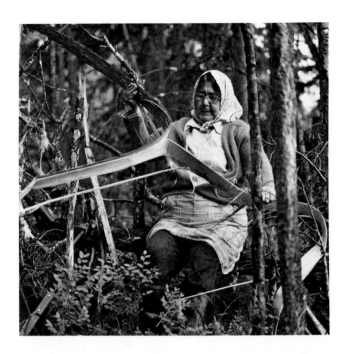

Separating the inner from the outer bark

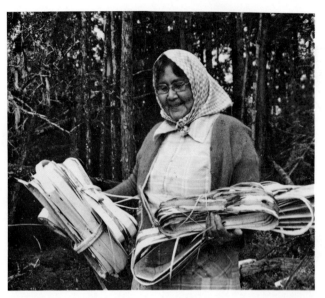

With cedar bark bundles

"Take it while you got the chance; you don't get a chance like this again! This is what Raven taught the people in the beginning."

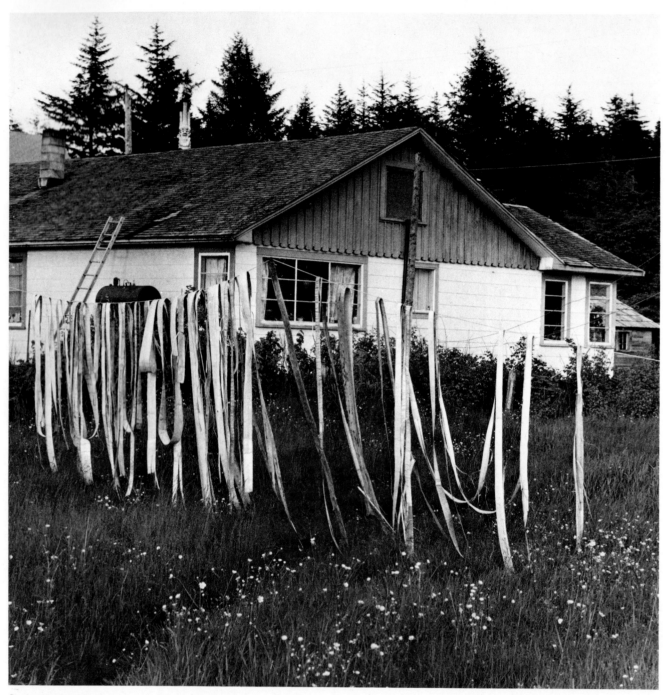

Cedar bark drying

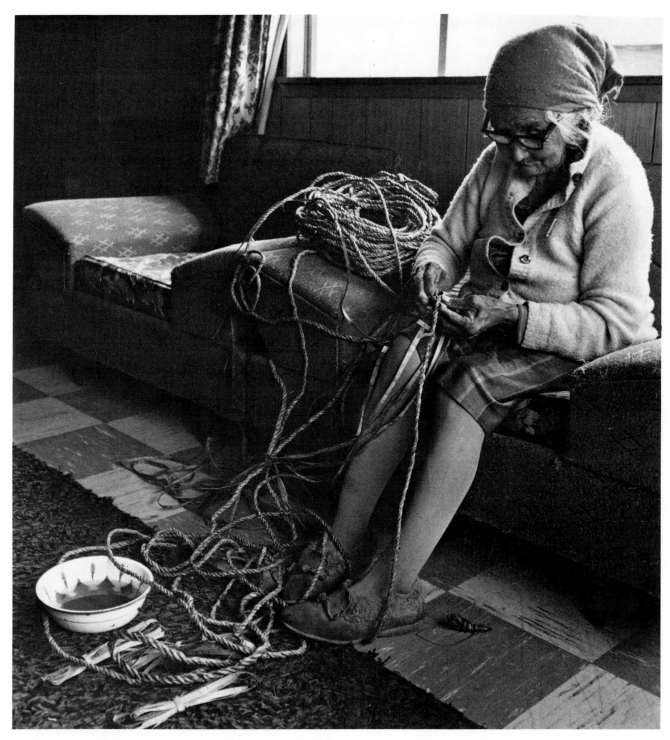

Hannah Parnell, Masset, making cedar bark rope. It will hold
fifty pounds and can be used for halibut fishing.

"Up here we get roots and barks in the summer when it gets warm."

"When will it be summer?"

"In August, maybe."

"When will it be over?"

"Maybe in August."

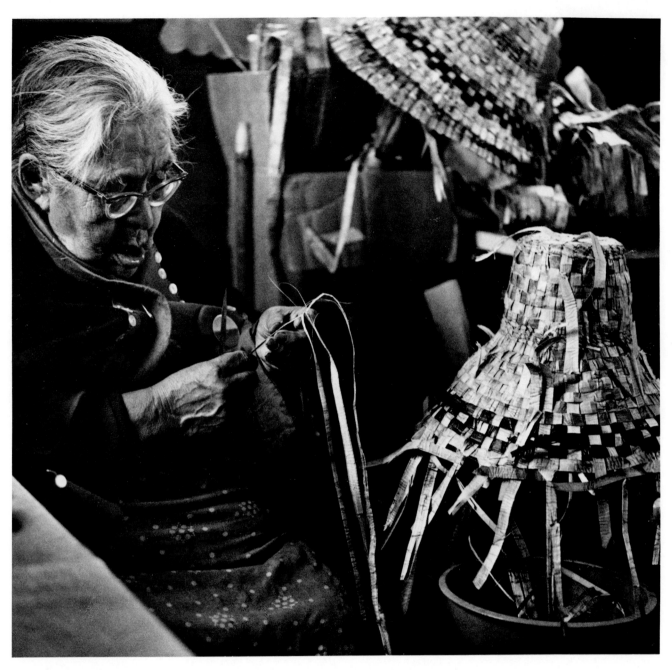

Eliza Abraham, Masset

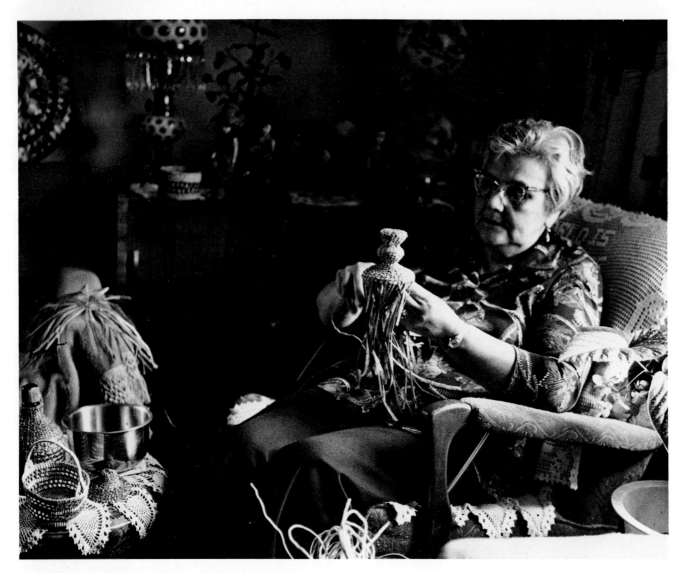

Nellie Yeomans, from Masset, now in Prince Rupert

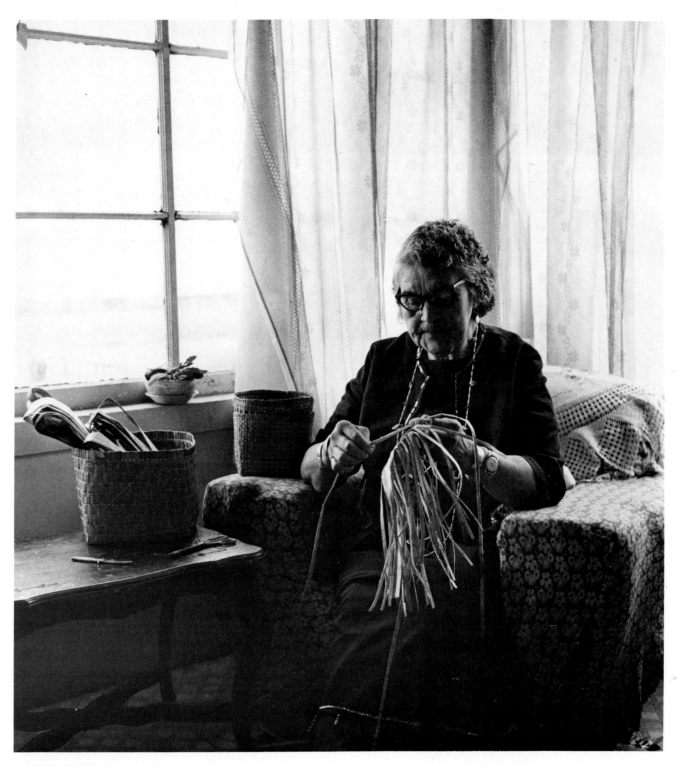

Carrie Weir, Masset

Florence Davidson, gathering spruce roots

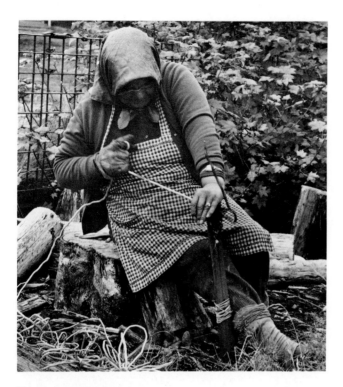

Skinning spruce roots

"When I retire I will only crochet.
I'll retire tomorrow… maybe."

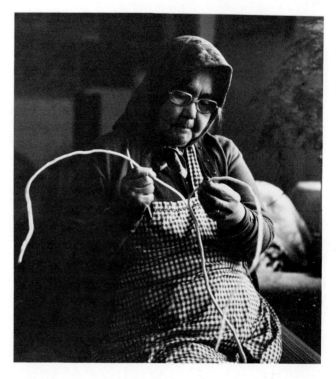

Splitting the spruce roots

"The roots are too thick for making a hat;
I will make a seaweed basket."

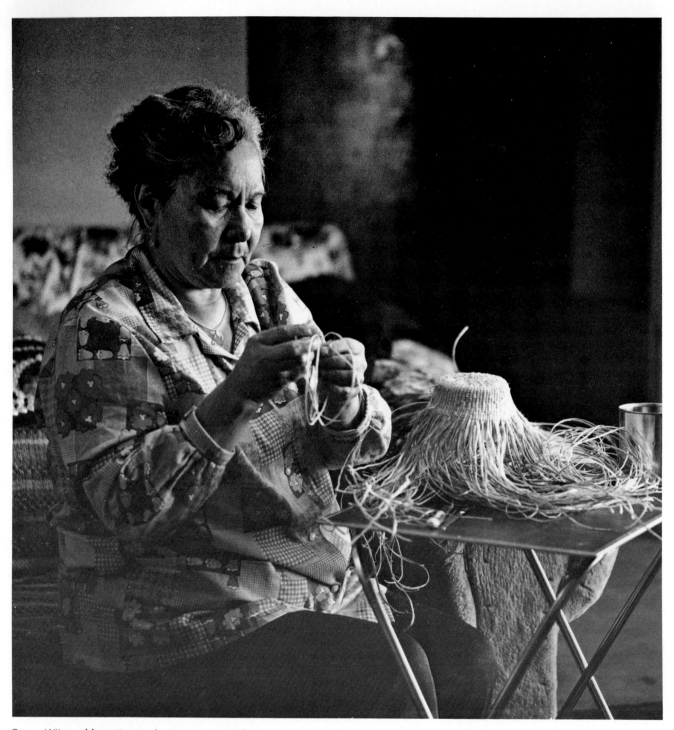

Grace Wilson, Masset, weaving a spruce root hat

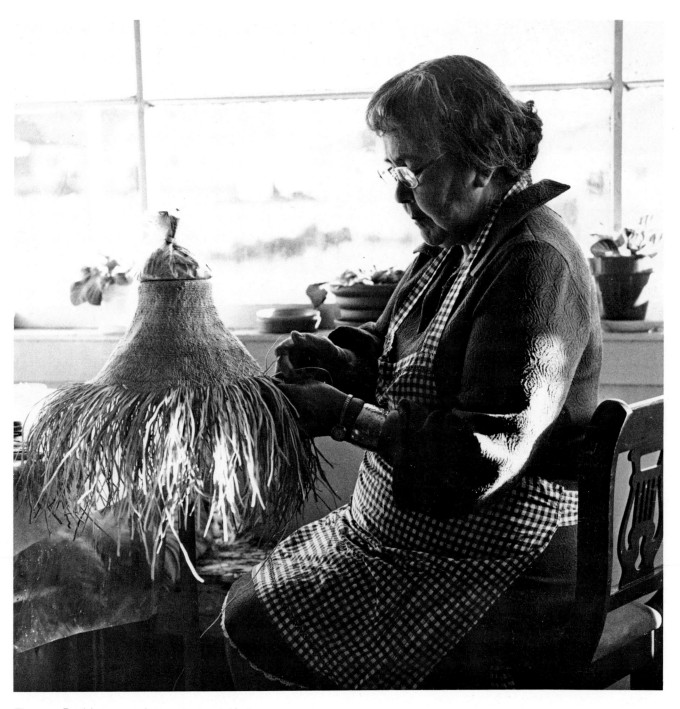

Florence Davidson, weaving a spruce root hat

KWAGUTL CARVERS
AND
BLANKET MAKERS

"Our people live at the northeast coast of Vancouver Island; Comox is the dividing line in the south, and Rivers Inlet in the north. We have always been fishermen.

"Our history was not in books — but it was carved into poles, masks, and talking sticks; put on blankets, and passed on to us as honor and authority."

—James Sewide, hereditary chief in the Kwekwasutenuuk, the Mamalelekala, and the Matilpi tribes

Larry Rosso, Vancouver: Carrier, adopted into the
Mamalelekala tribe through his wife, Alice. Larry is preparing
a steam-bent box.

Steaming the wood in a plastic bag

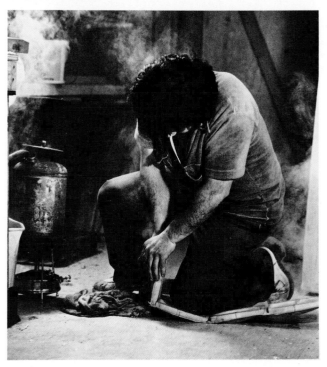

Bending the wood

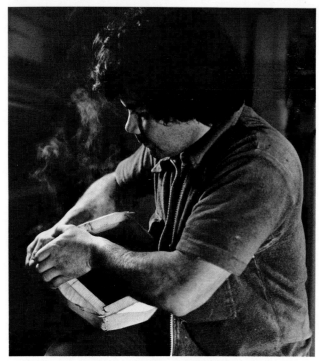

49

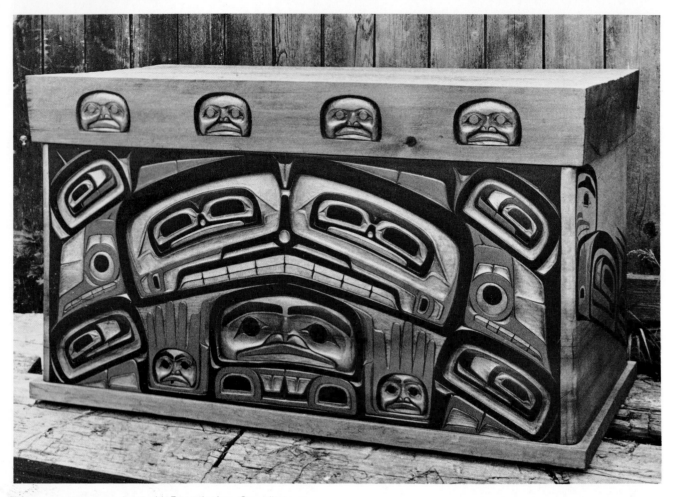

Steam-bent storage chest with Bear design, Guardians on
the lid, red cedar, by Larry Rosso

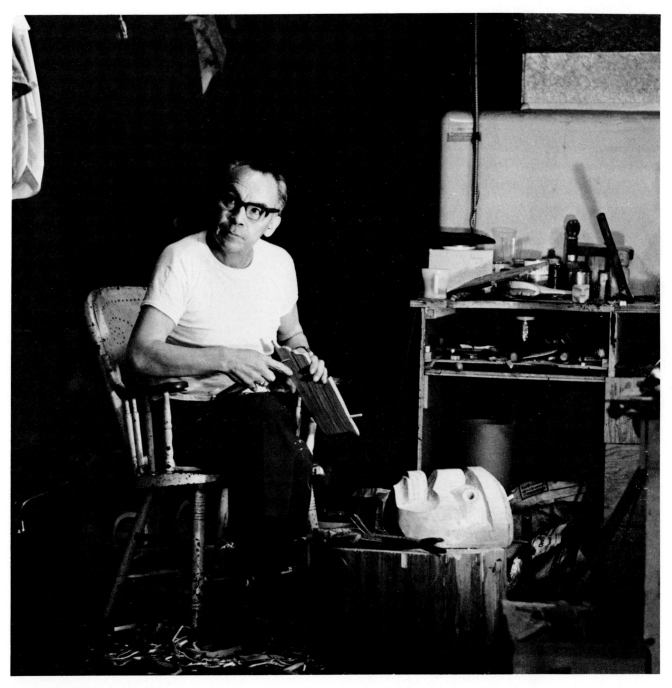

Henry Hunt, from Fort Rupert, now in Victoria, carving a
Kingfisher mask

"I've been carving for the Provincial Museum for a long time. I
made poles that are all over the world: big poles, small poles,
lots."

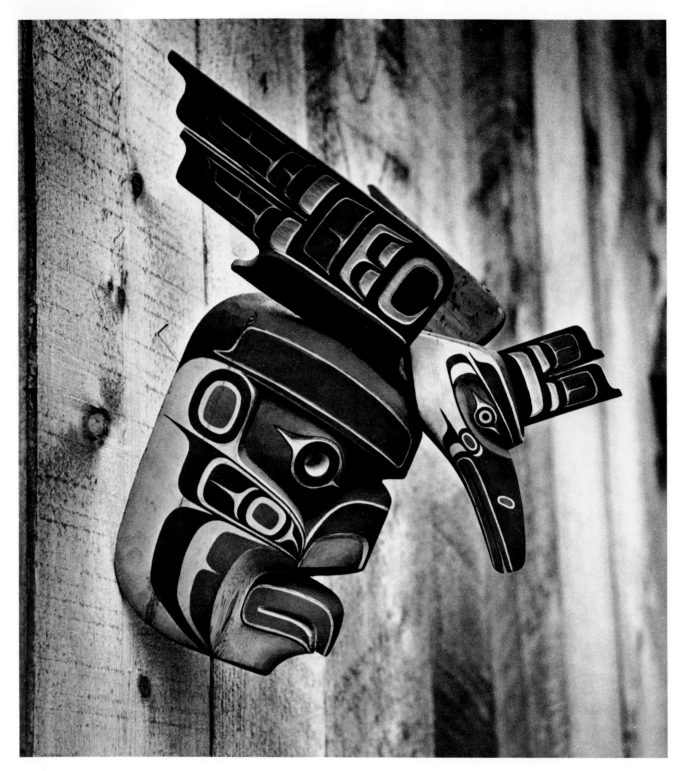

Kingfisher mask by Henry Hunt

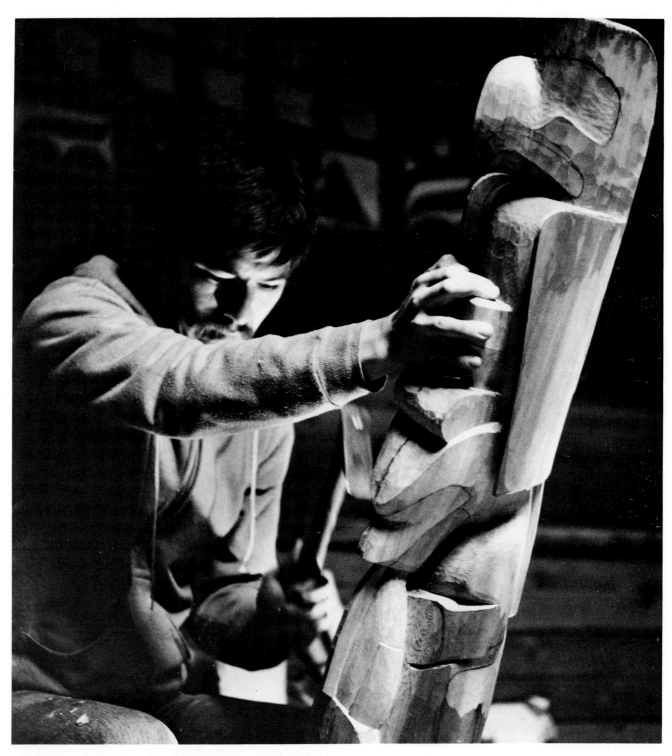

Richard Hunt, from Fort Rupert, now in Victoria, carving Bear
and Bullhead pole

"My father showed me everything
I know.

"I will stick to wood until I really know
how to work it, I mean really good like my
father can do with his eyes closed.

"I am Head Carver at the museum now;
I took over from my father. Being a
full-time carver is traditional.

"I like to make masks for ceremonial
use. But I have to be asked by the person
who is having the potlatch to carve one."

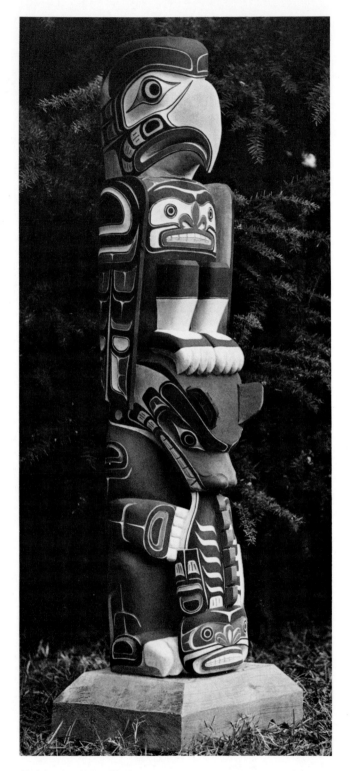

Finished pole by Richard Hunt

54

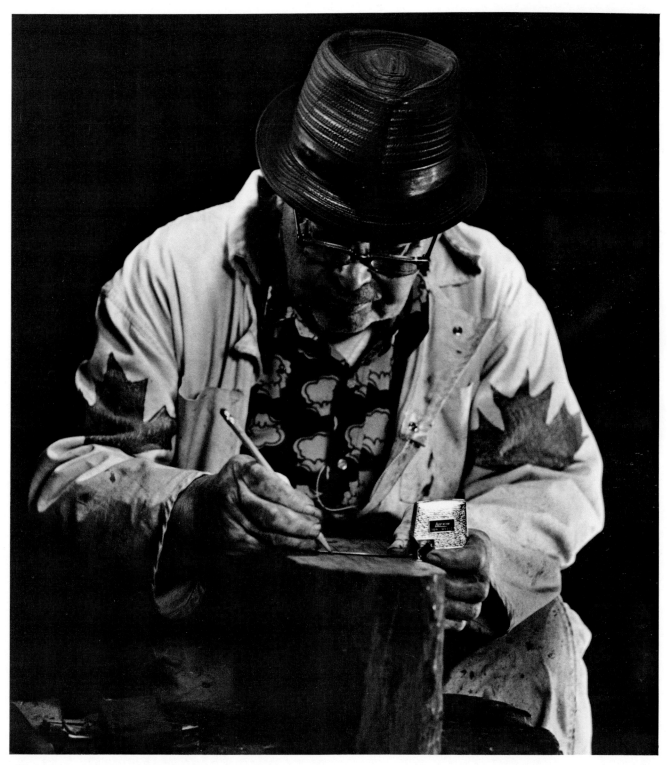

Jimmy Dick, from Kingcome Inlet, now in Alert Bay

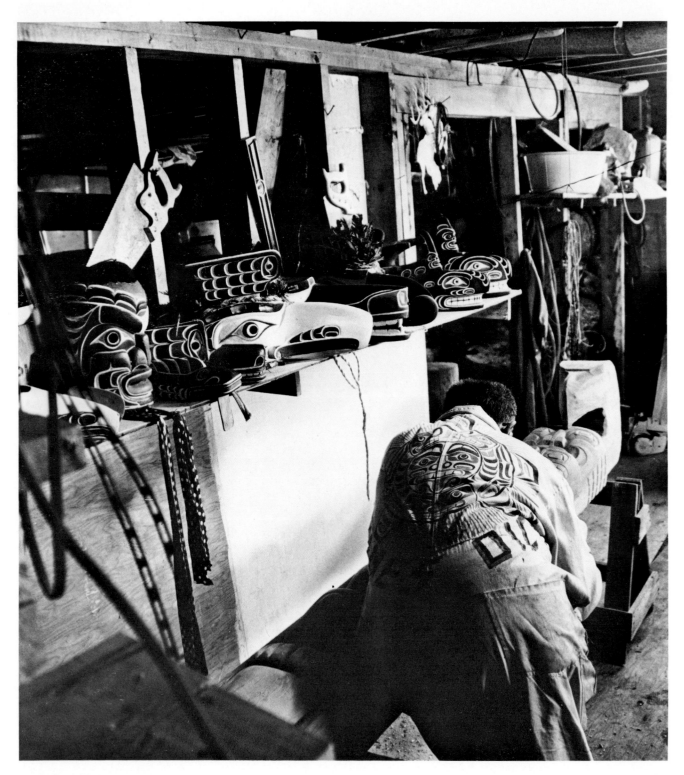

Jimmy Dick in his workshop

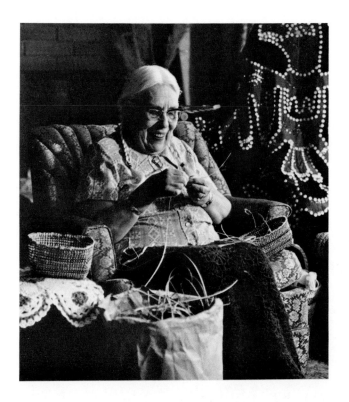

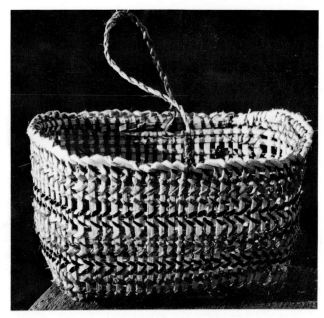

Cedar root and cedar bark basket by Agnes Alfred

Agnes Alfred, from Mamalelekala tribe, Village Island, now in Alert Bay

"I am the only one who makes these baskets today. We used to make big ones for clams, fish and berries. I use cedar root and cedar bark.

"They used to teach me everything. We did not only get roots for making baskets, but also many different roots for eating."

The Indian blanket, which was made by Agnes Alfred for James Sewide, shows the Kolus—a cousin of the Thunderbird—which is one of Chief Sewide's crests.

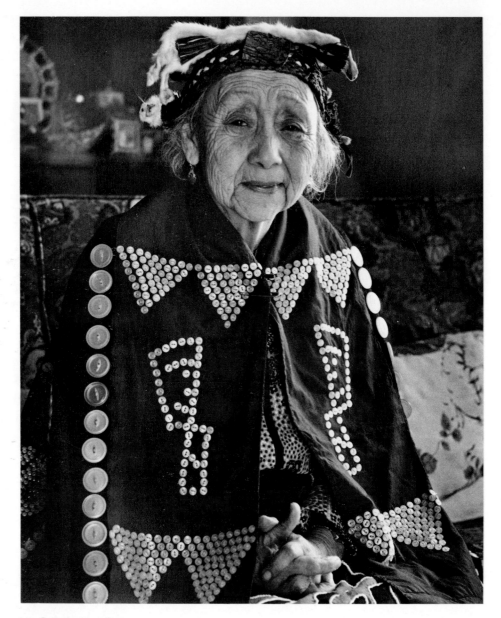

Lily Speck, Alert Bay

"My husband, Henry Speck, made the design. I did the sewing. The Thunderbird is my family crest."

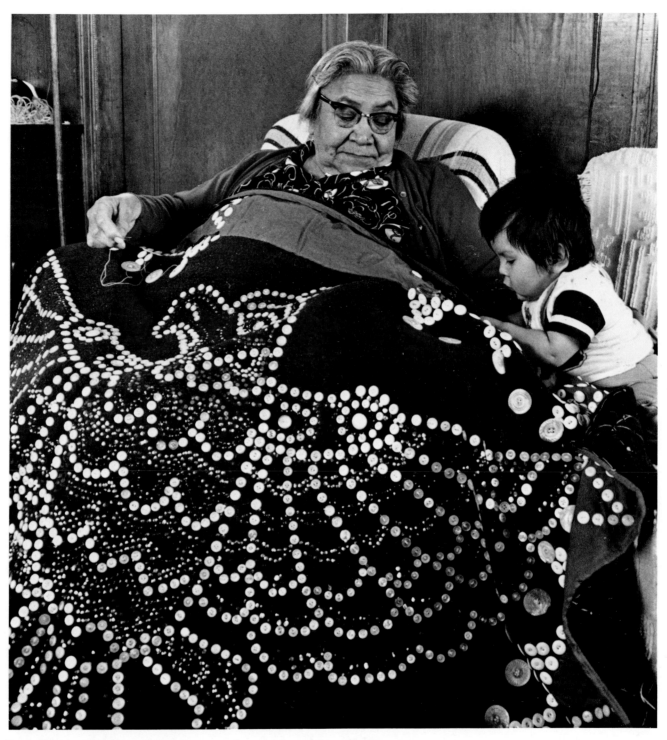

Emma Beans, Alert Bay
Indian blanket with Eagle design in buttons, abalone, and
sequins. She is making the blanket for her daughter.

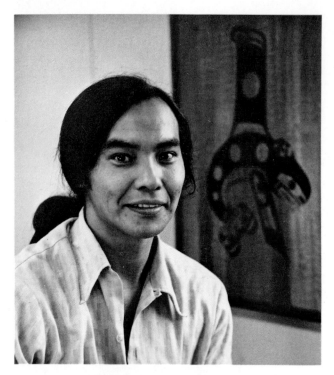

Roy Hanuse, from Owikeeno tribe, Rivers Inlet

"I started with painting traditional designs. The carving came later, but perfecting my designs helped me a lot with the carving."

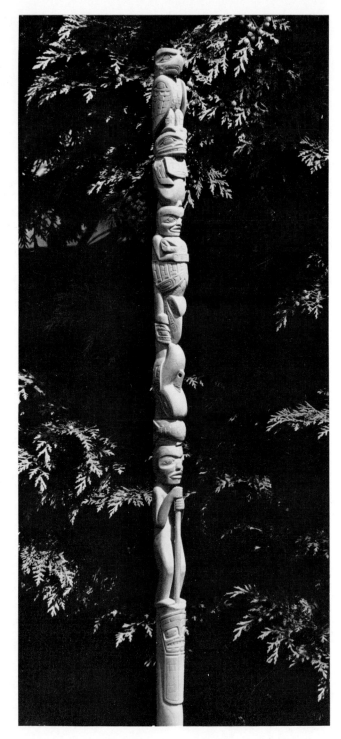

Talking stick, yellow cedar, by Roy Hanuse; the figures are Copper; Man; Salmon; Killer Whale; Man holding a Raven; Whale, and Eagle.

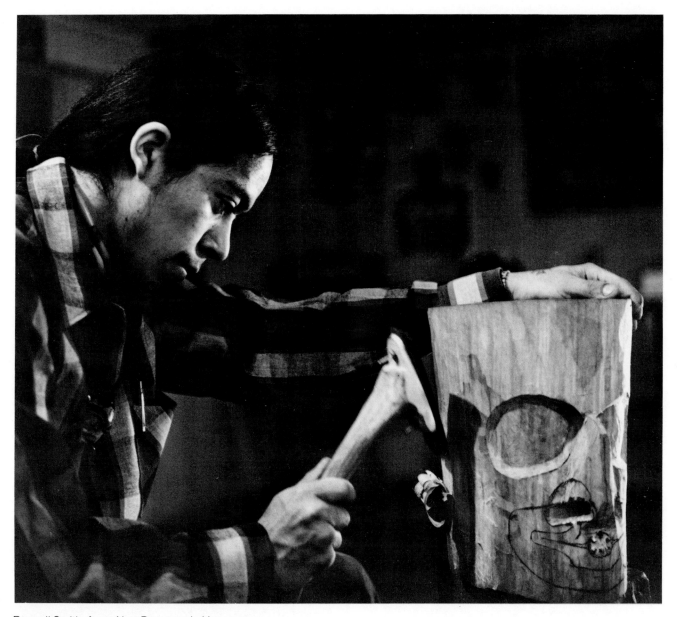

Russell Smith, from Alert Bay, now in Vancouver

"I like to make masks because I like to see them used in dances. It would take a lifetime or more to carve all the different masks of my tradition."

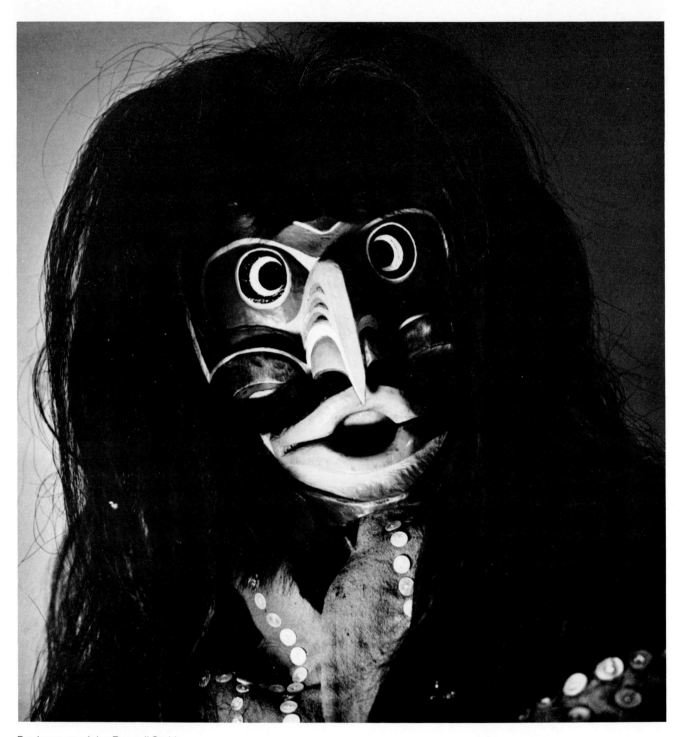

Bookwus mask by Russell Smith

"The Bookwus is a supernatural being who entices humans to eat the food he eats, so they become beings just like him."

WEAVERS AND
CARVERS OF
VANCOUVER ISLAND'S
WEST COAST

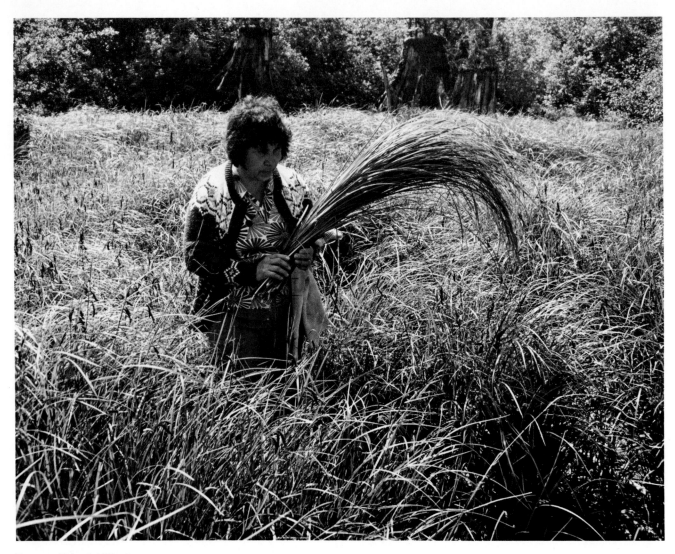

Frances Edgar, Nitinat

"I use swamp grass, cedar bark, and three-corner grass for the baskets. I pick the swamp grass in August when it is long enough, when it is just right. In July it is too soft and narrow. I started out making baskets when I was eight years old. At that time we used cedar baskets to gather berries and seafood and kindling driftwood. We made grass baskets, too, and put the designs on them. The white people have always liked to buy them from us."

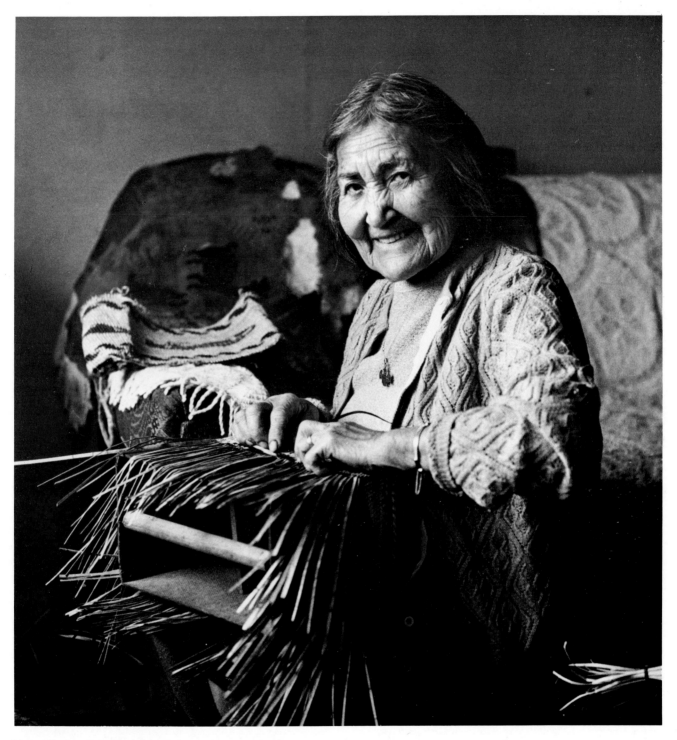

Mabel Taylor, Port Alberni, weaving a shopping basket
around a wooden basket form

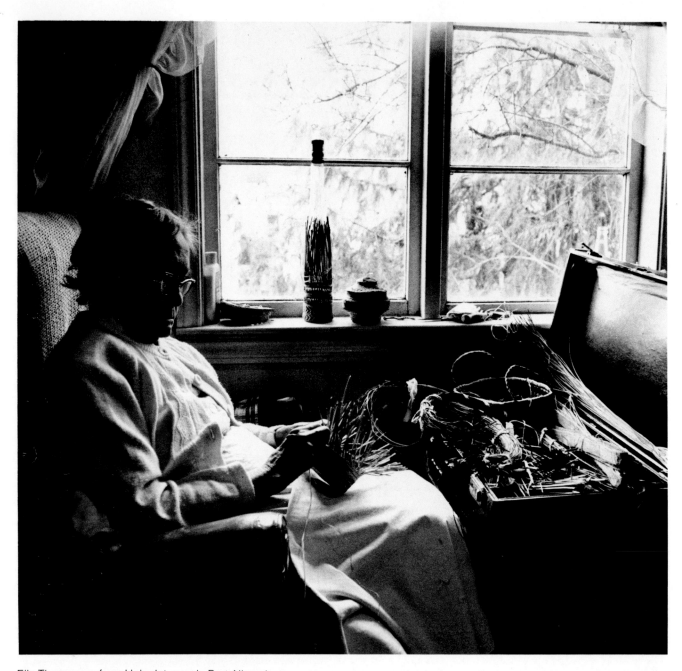

Ella Thompson, from Ucluelet, now in Port Alberni

"Everybody that was a lady made baskets long ago; now it is
only some of them."

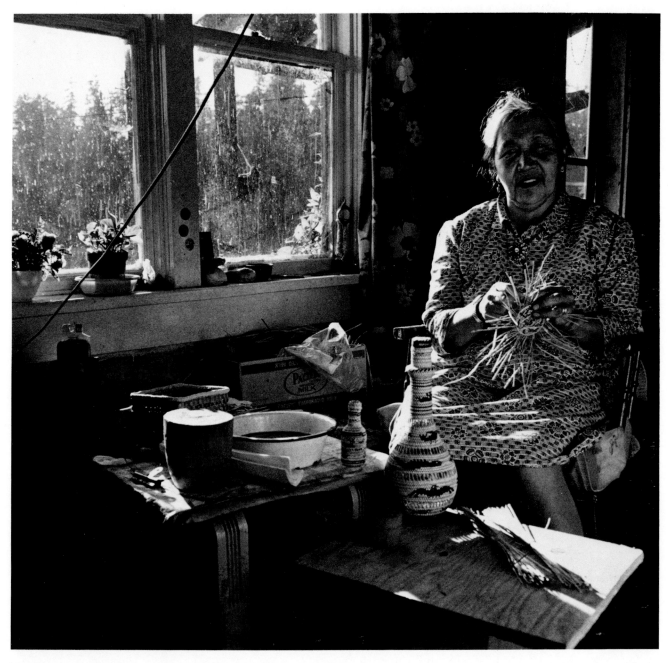

Liz Happynook, Bamfield, using designs handed down to
her by her aunt

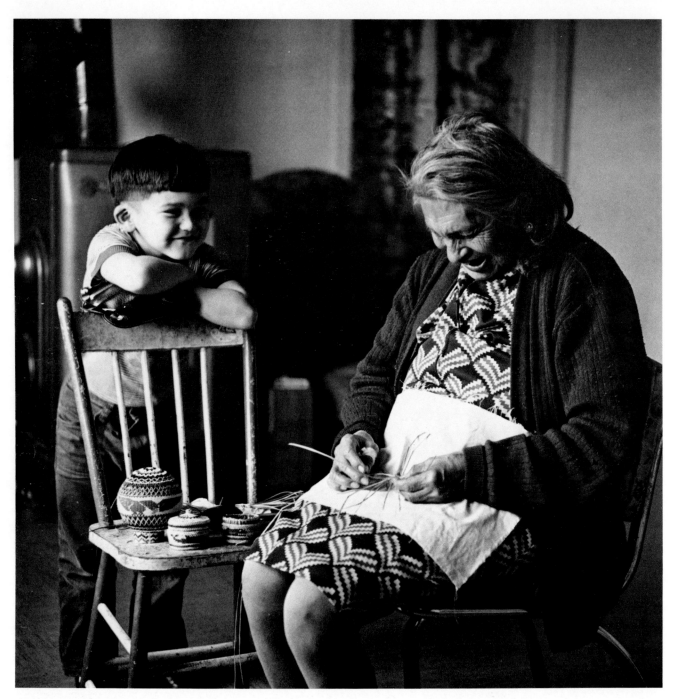

Ellen Jumbo, Port Alberni

Mike Tom from Hesquiat and Josephine Tom from Nootka,
now living in Victoria

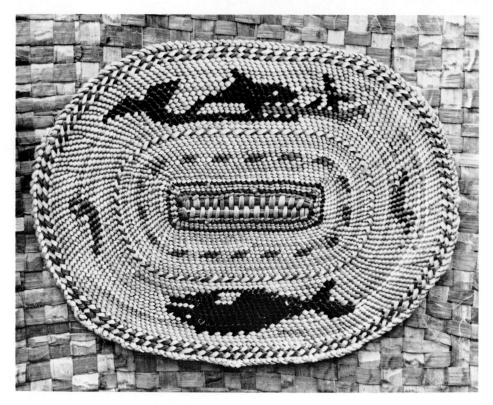

Whale and Halibut mat by Josephine Tom

Mike Tom tells two related legends:

"Sores, he was the strongest man up on the west coast. He killed the biggest whale on the west coast, but he died getting the halibut.

"He went with his uncle to get the big whale that had swallowed up all the canoes, but there was none. But when they saw it on the west side of Sandy Rocks, the uncle said: no, no, no. He was so scared, he knew they were going to die so he put down his paddle. Sores told his uncle to steer, but the uncle was not steering any more—he was ducking down. So the nephew steered into the whale's mouth and put the spear in its throat where it is narrow. The uncle could not stand it any more. So Sores paddled back out, and when the uncle saw that they were out again, he told his nephew to hide behind the rock so if the whale starts kicking around, they don't drown in the waves.

"This is when he went to get the halibut. Many had lost their lines and hooks: there must be a big fish! But they never saw it. They made a big hook and a big line, and Sores went out with his uncle again, and waited and waited. He got so sleepy that he tied his line to his foot and told his uncle to tell him when the fish bites. He put his foot on the side of the canoe and lay down. When the fish is biting, the uncle has no time to tell him. He gets pulled out and goes down with the big halibut. He opens up its throat and kills it, but he notices that he can't get back up because it is too deep. So he ties himself together with that halibut. They find him on the beach at Cape Cook tied up with the halibut that had taken all the hooks and lines. It is called the Halibut Bank of Estevan Point, four miles off Hesquiat."

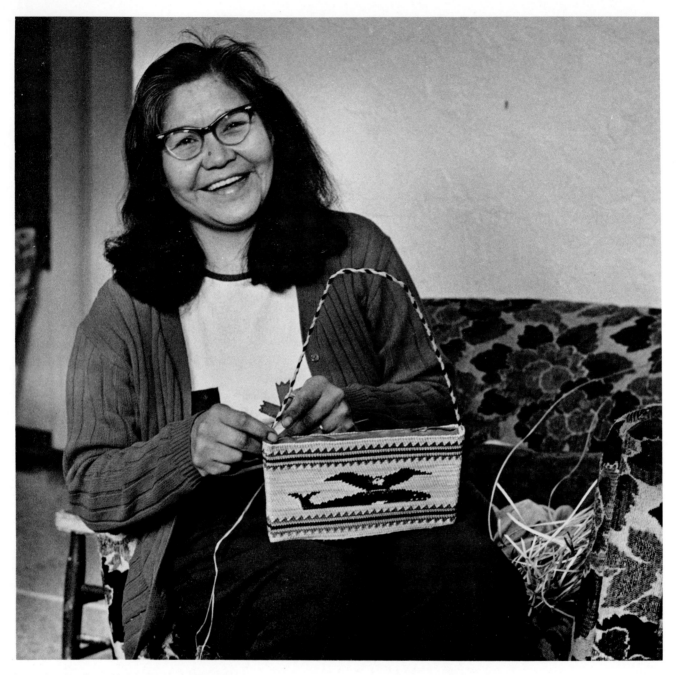

Lena Jumbo, from Ahousat, now in Victoria

"You know, you can weave without looking as long as it is one color. I learned to weave when I was five—my grandmother used to leave my work at the door, and when I came in from playing she'd say my work was crying for me."

74

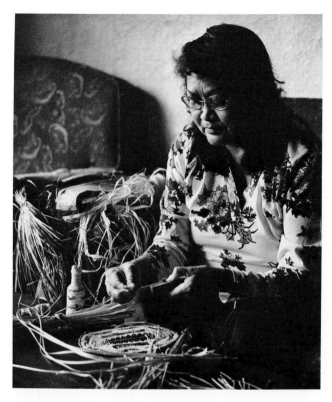

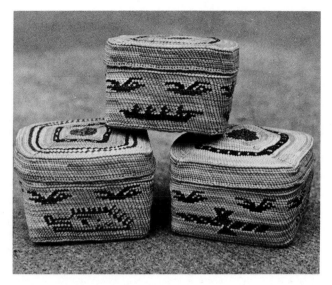

Baskets by Josephine Thompson

Josephine Thompson, from Ahousat, now in Port Alberni, thinning the grass between two blades

"It's the Sea Serpent, and they say when it spit, that made the lightning. It was sort of wrapped around the Thunderbird's neck. We don't have an Eagle in our stories, just the Thunderbird. But nobody has seen him. So we just make him up any way we like it.

"They used to tell us stories every night—there was nothing else to do. I remember all of them, but I forget the end because I would fall asleep before it was over.

"Next time I see you, maybe I tell you about flying saucers."

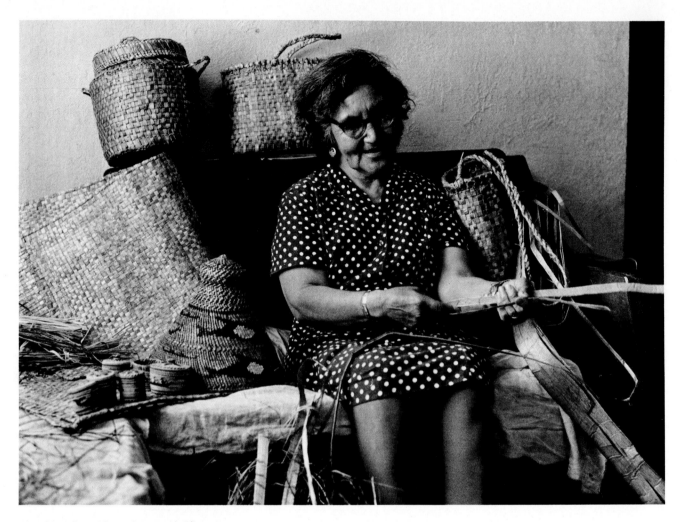

Alice Paul, from Hesquiat, now in Victoria

"We go home to Hesquiat every year when it is time to pick cedar and grass. In May it is really good bark; later the pitch runs on it.

"The hats we put oil on: fur seal oil, whale oil, dogfish oil, or hair seal oil. We put the Whale in our designs because it was really important for trading and food and bones and teeth to make tools and combs.

"My parents, every night they were home and tell stories, stories, stories… of animals and the birds that had been a person long, long ago."

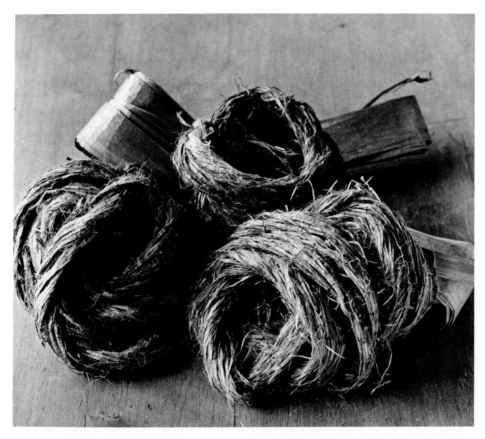

Cedar bark diapers by Alice Paul

"Nobody was born inside; all the babies were born in the bush. My mother, too—she was born in the woods. The woman would be all alone and cut the cord with a clam shell and stick some fine thread into the baby's navel. Then she has cedar bark like this all ready with her and a little basket, and she puts the baby in there and brings it back to the house. They used the very best bark for the baby—from way up the mountain—and put it under the baby and cover it, too, so only the face and feet would show. That's what they used for diapers and, you know, the woman used it too."

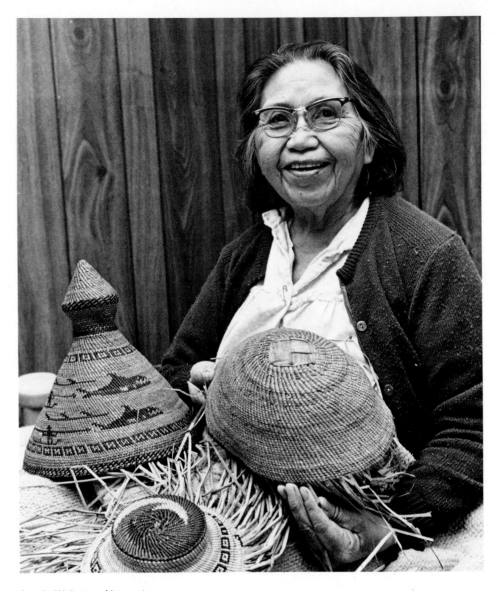

Jessie Webster, Ahousat

"There are two kinds of hats: one for the chief, and plain ones for the people. My grandmothers, I used to watch them. They would start one for me, and then I worked on it."

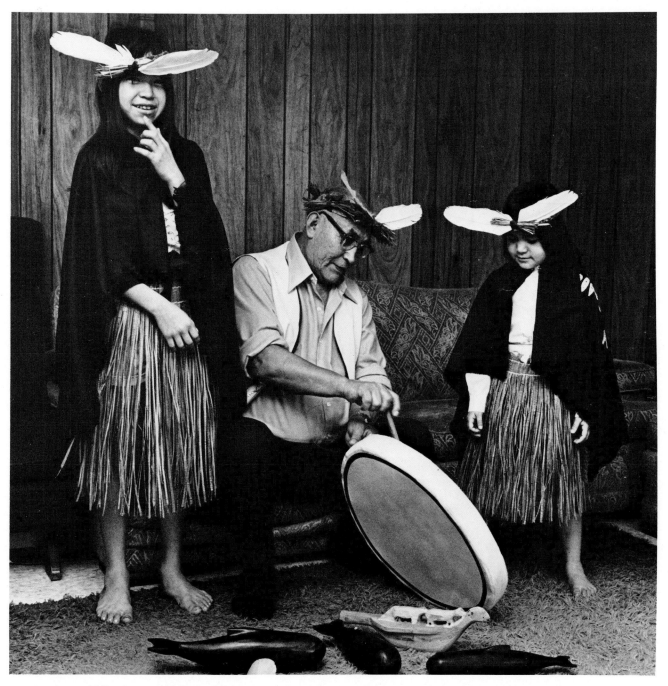

Peter Webster, Philomina and Melinda, Ahousat

"I teach my grandchildren the dancing. All the costumes they are wearing are made by Jessie, their grandmother. I do the carving of the rattles and the masks."

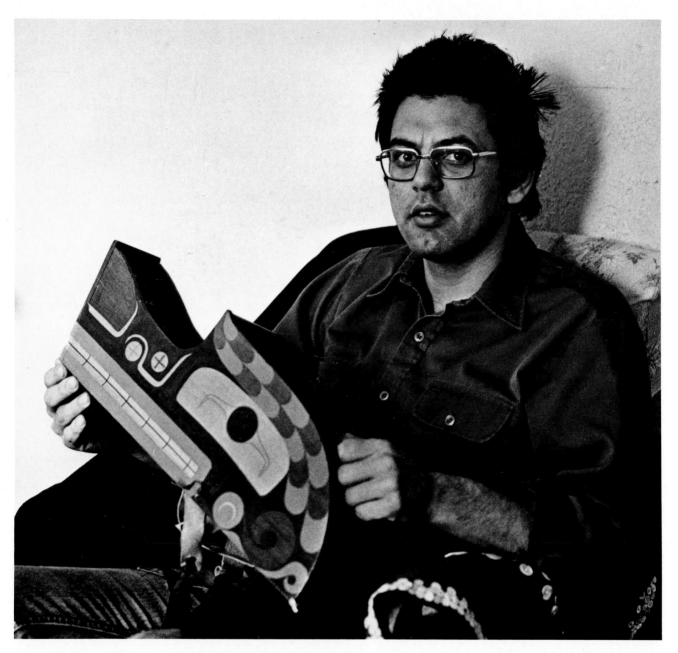

Ron Hamilton, Port Alberni, with Sea Serpent headdress

"Our west coast style of design and carving is much more naturalistic than that of the tribes from farther north. Both carvers and basketmakers draw their designs mostly from nature. The Sea Serpent can be found on baskets, bracelets, drums, boxes, blankets, and also in songs."

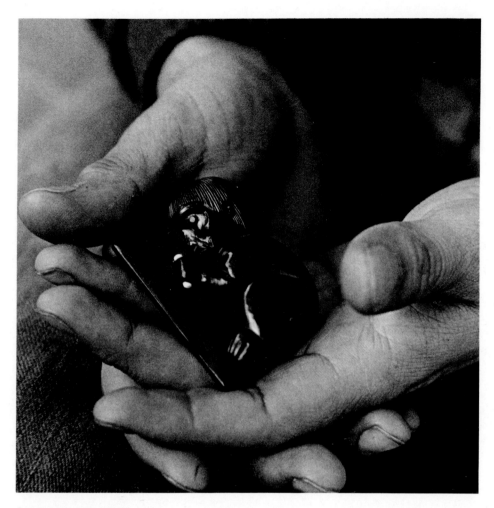

Carving by Ron Hamilton

"This is a portrait of my younger son, Johnson, on his first birthday. It is a piece of slate that came from right near Campbell River. It is harder than the slate that the Haidas carve."

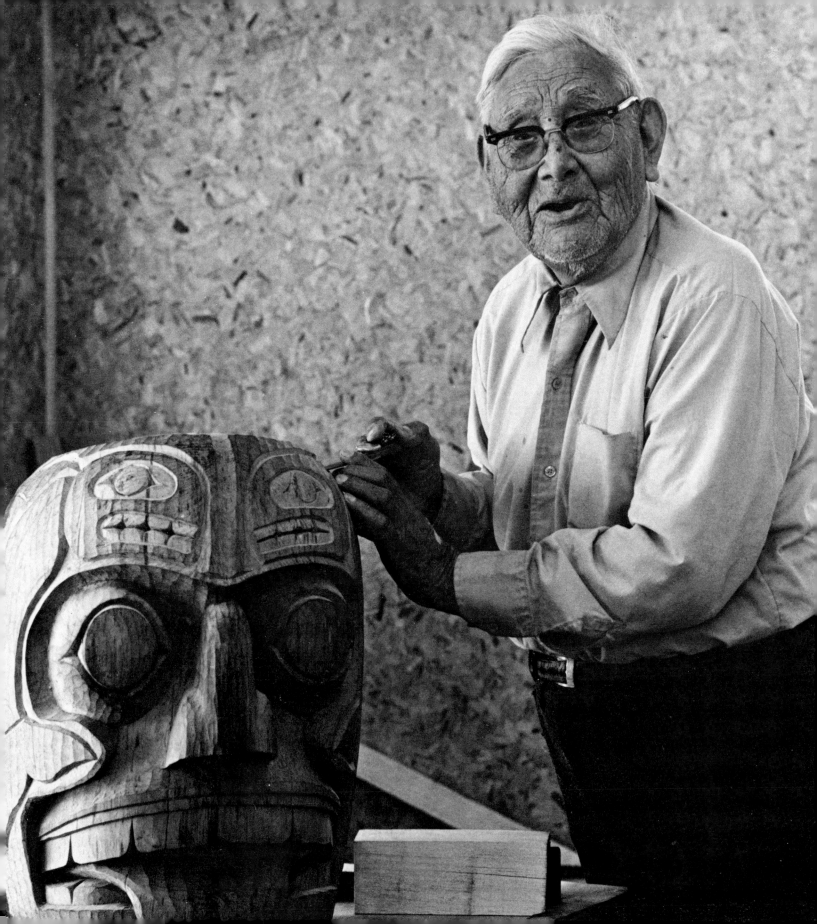

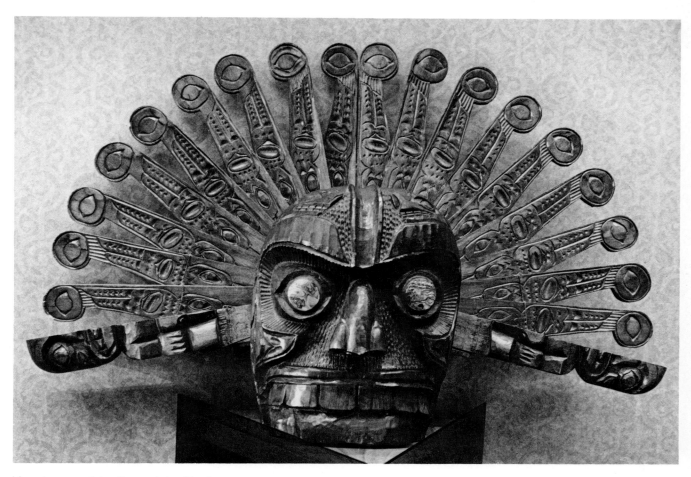

Maquinna mask by Jimmy John, Nootka carver
Born in Friendly Cove, Jimmy John has lived in Cedar, near
Nanaimo, for half a century. Close to a hundred years old, he
is a direct descendant of Chief Maquinna.

COWICHAN KNITTERS
AND
SALISH WEAVERS

"If a family was going to have a potlatch they hired a man to carve this figure. The two open hands are thanking the people for coming. The Welcome Man is my own version of the traditional figure. I carved it the way my uncle described it to me. When he saw it he said that it was just like the one he remembered."

Welcome Man by Simon Charlie, carver from Malahat tribe
Courtesy of Dr. and Mrs. Norman Todd, Chilliwack

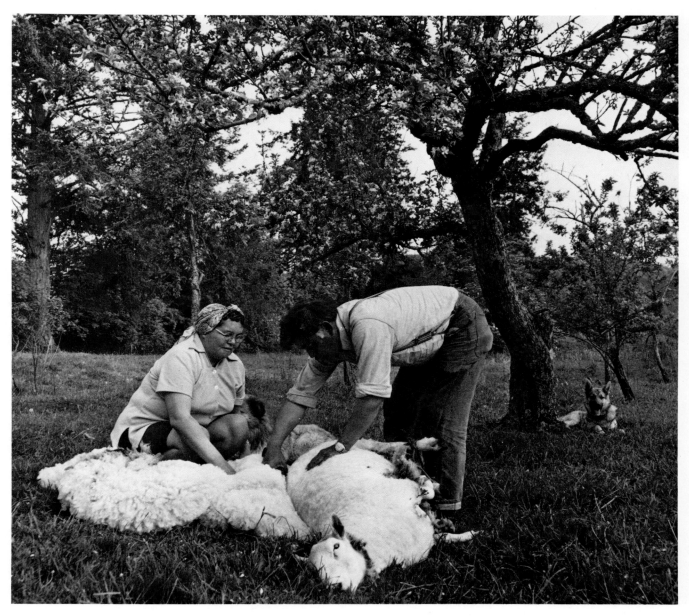

Dennis and Marge Charlie of Penelakut Reserve on Tussie
Road, shearing "Sam" the ram

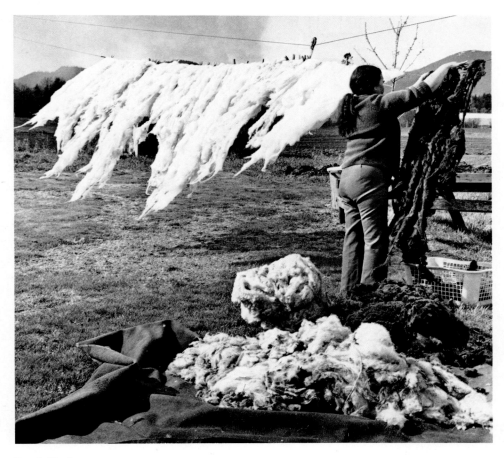

Sarah Modeste

"The wind, it helps us to clean the wool and to dry it. The sun helps to dry and to bleach it, and the frost at night, it bleaches it too."

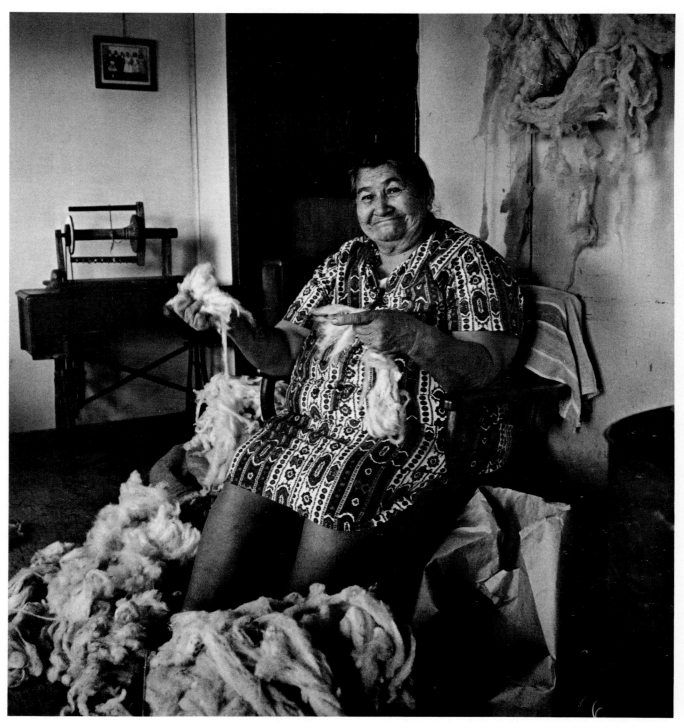

Hilda Henry, Khenipsen Reserve, teasing the wool to loosen
and to clean it

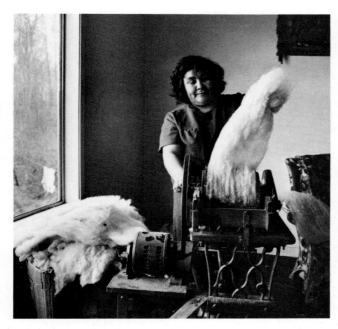

Evelyn Joe, Comiaken Reserve, carding the wool to prepare it for spinning

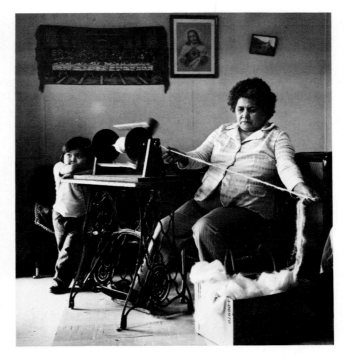

Madeline Modeste, Koksilah Reserve, spinning the wool with a transformed treadle sewing machine

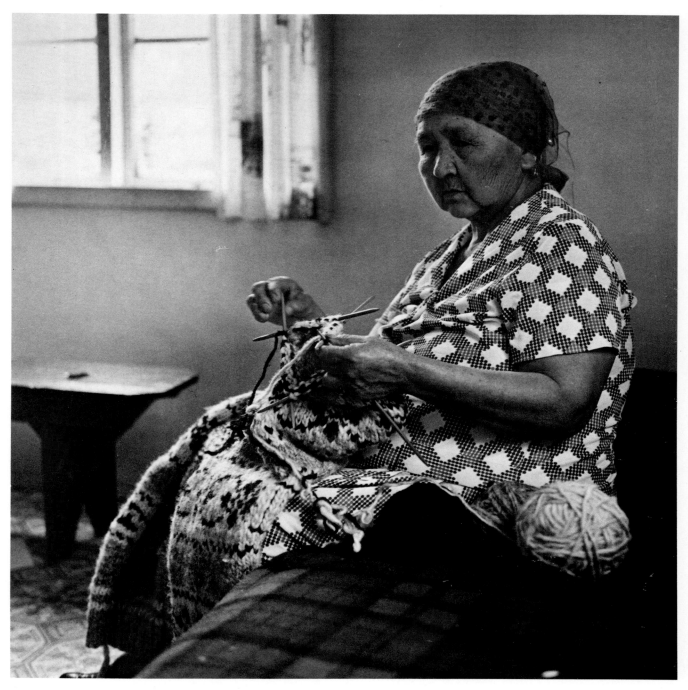

Monica Joe, Comiaken Reserve, a lifetime knitter

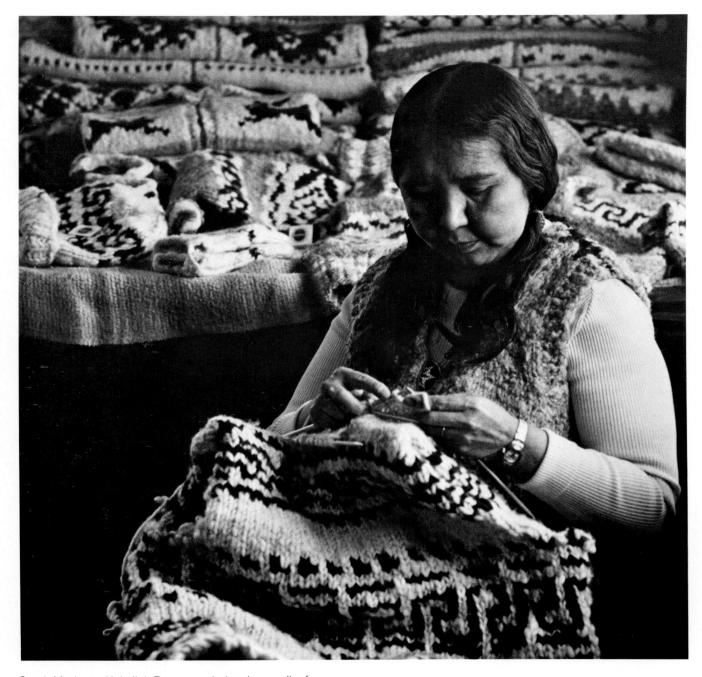

Sarah Modeste, Koksilah Reserve, wholesale supplier for
Central Marketing Service, Ottawa

"Many of us process our own wool. It takes up a lot of space and time, but the sweaters last much longer."

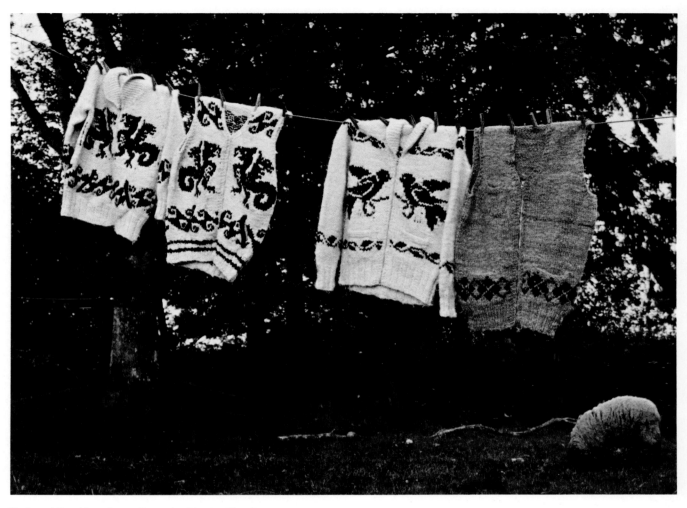

Bird and Sea Monster patterns by Marge Charlie

"Both these designs were given to me by my mother. They have been handed down from generation to generation.

"The Bird is just a local bird. The Sea Monster, I don't know, it was usually at the west coast but it might have been also down at Cowichan Bay. We never saw it up here, but then, we don't live that close to the water."

"If it were not for Oliver Wells we might not have ever known about our Salish weaving again. It was his interest and the research he did in his spare time that got us started. Mary Peters was the first weaver. That was in 1963. After her there were more and more women learning to weave. We formed a club, the Salish Weavers, and by 1973 started our store. By now we have about 40 members from eleven local reserves. Everybody has her own little job. You see, if I can't get the right dye, then Nora will. And sometimes she can't get it, and I will.

"It was a long time after Oliver died before I was able to talk about him—I always felt I wanted to cry."

Josephine Kelly

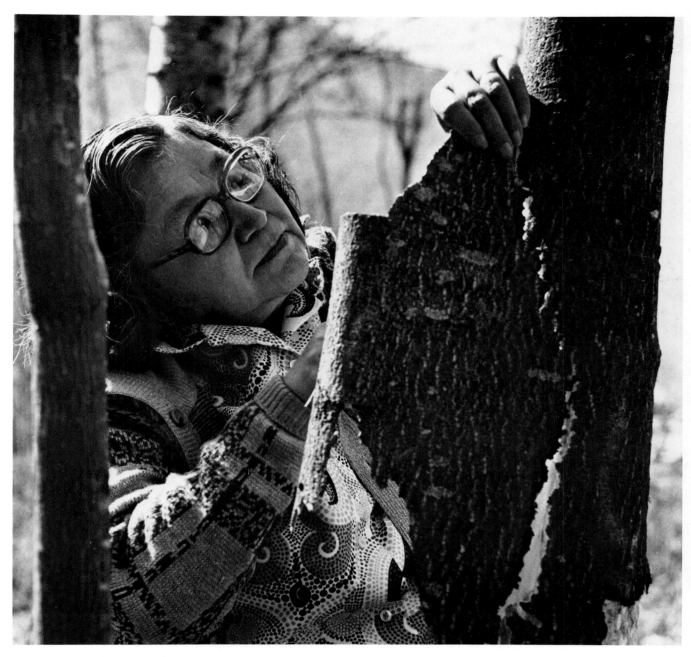

Josephine Kelly, Soowahlie Reserve, taking the bark off a
cascara tree

"You are always learning, there is always something else to try
out in dyeing. It depends on the time of the month and the
weather what shades of color you get from a particular plant."

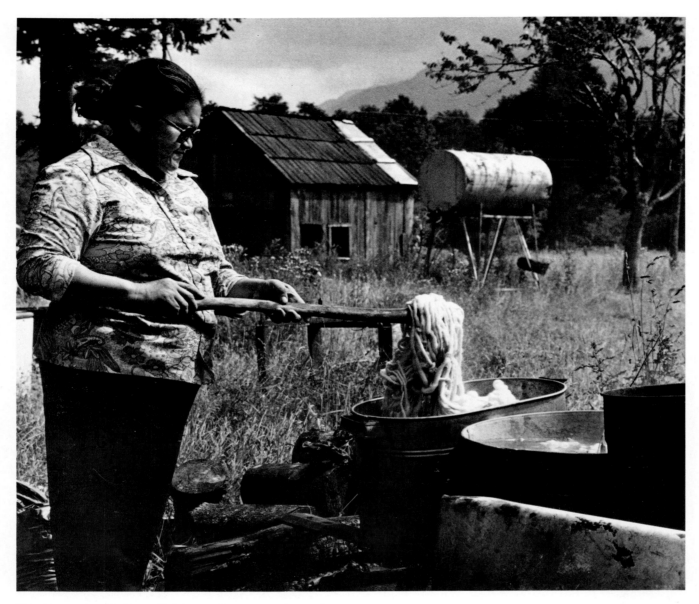

Nora Peters, born in Green Point, near Duncan, and now of
Peters Reserve, Laidlaw. President of the Salish Weavers,
Nora spins and dyes for them.

"All my family is working with wool. My mother and sisters are
all knitting. And my little nephew, he just made his first
sweater; it's real pretty. My three girls and one of my boys are
weaving, and my husband, he helps me with everything. He
made my spinner and my carder and he cards the wool, too."

Norma Peters and Doreen Kinnaird

Dye baths of cascara, brown-eyed Susan, and cherry bark

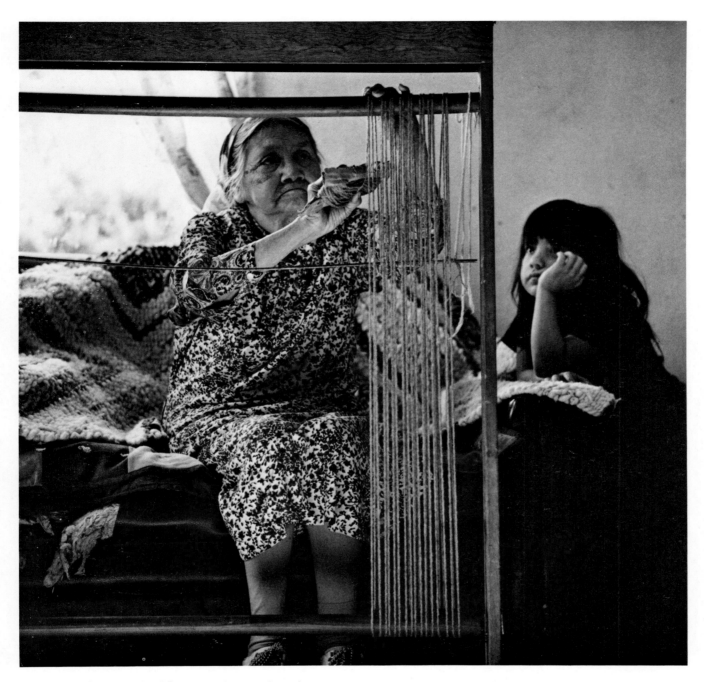

Mary Peters, Seabird Island Reserve, who was the only
person weaving when Oliver Wells discovered that Salish
weaving had nearly died out

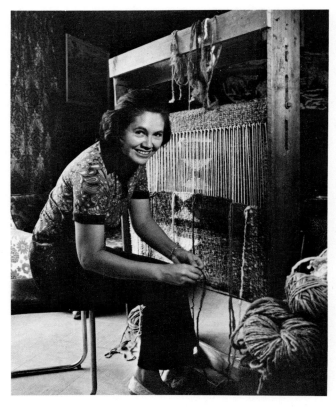

Anabel Stewart, from Soowahlie Reserve, married into Skwaw Band

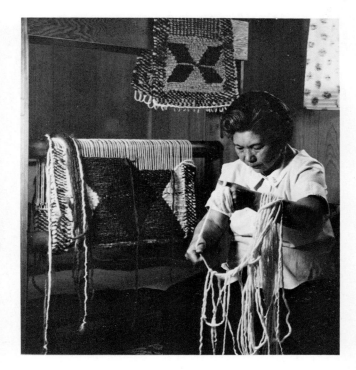

Theresa Jimmie, Squialla Reserve, Chilliwack. Theresa teaches spinning, knitting, and weaving for the Salish Weavers.

"Oliver Wells used to take my great-grandmother's rag rug around to the people to teach them the old way of weaving. They would each unravel a bit to find out how it was done.

"Now I weave so much that when I don't work for a while, my hands get restless."

Margaret Jimmie, Squialla Reserve

Martha James, Skwaw Reserve, Chilliwack

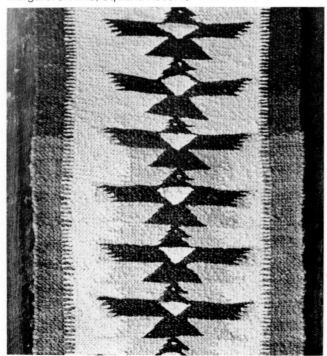

Weaving by Margaret Jimmie

Blanket by Martha James
Courtesy of Dr. and Mrs. Norman Todd

Mary Peters

Margaret Emery, Yale. From the raw fleece to the finished weaving, she does eveything herself and completes two rugs a year.

Detail from blanket by Mary Peters. The symbol in this weaving is the flying goose. It has become the symbol of the revival of Salish weaving.

Detail from weaving by Margaret Emery
Courtesy of Dr. and Mrs. Norman Todd

101

THOMPSON,
MOUNT CURRIE,
AND COASTAL
BASKET WEAVERS

Mount Currie

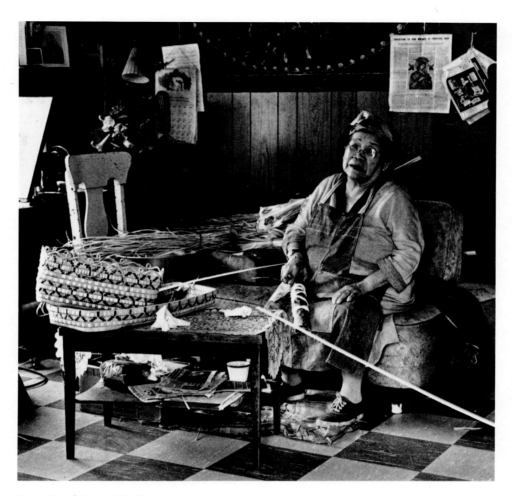

Rosie Ross, Mount Currie

"Are you a 'Salish' woman?"

"I was born in Lillooet and I live in Mount Currie."

"Then, are these 'Salish' baskets?"

"I guess you can call them that. They're for sale."

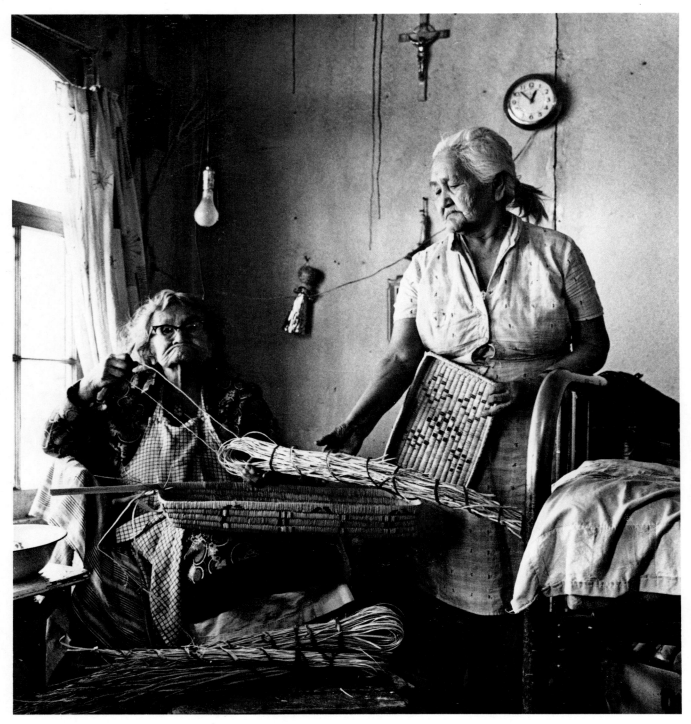

Matilda Jim, well over one hundred years old, and her
daughter, Julianna Williams, Mount Currie

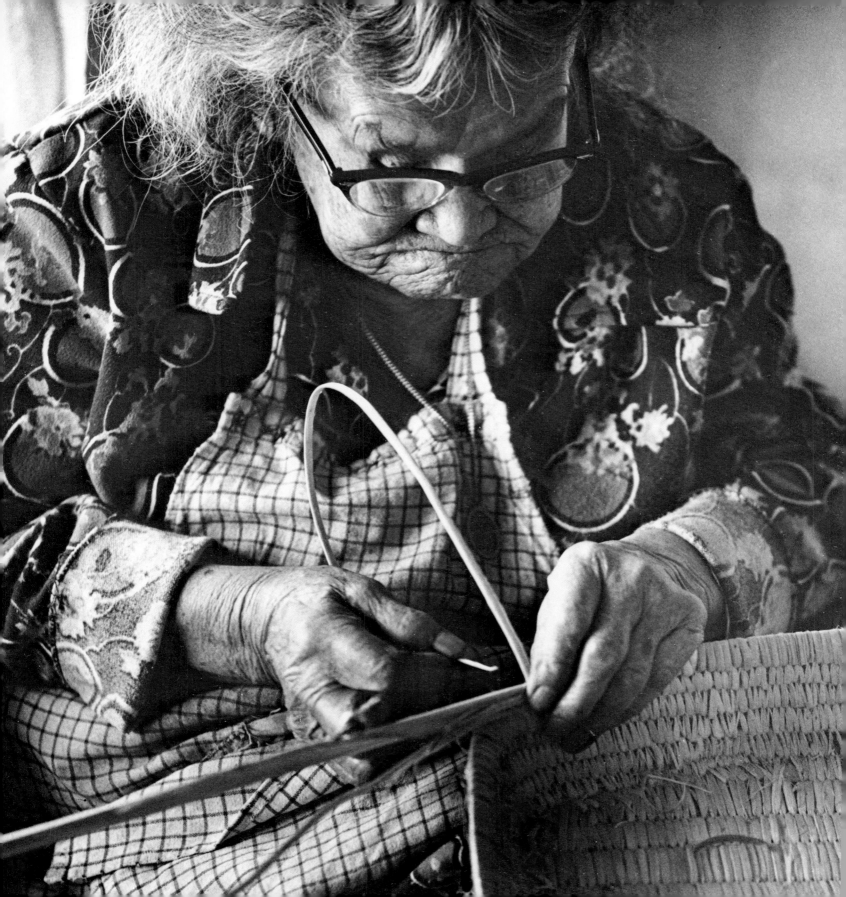

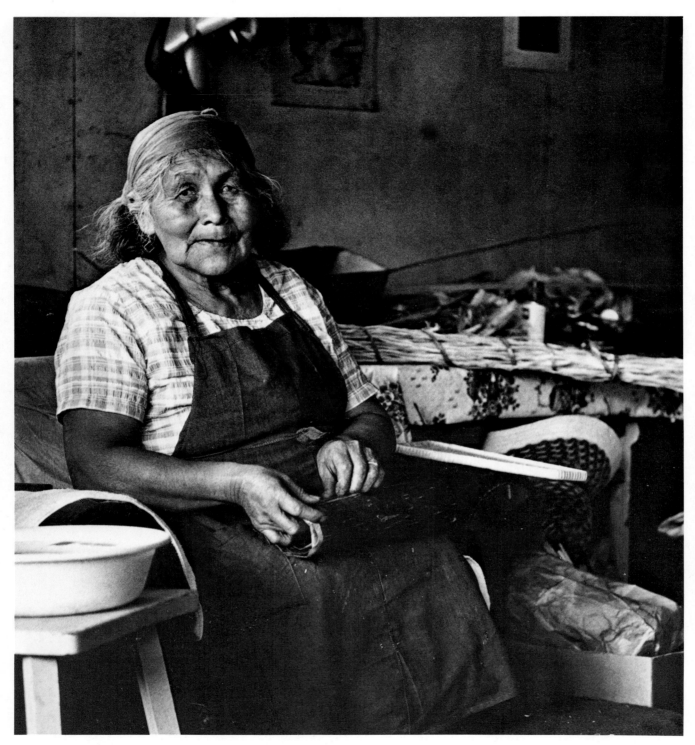

Felicity Dan, Mount Currie

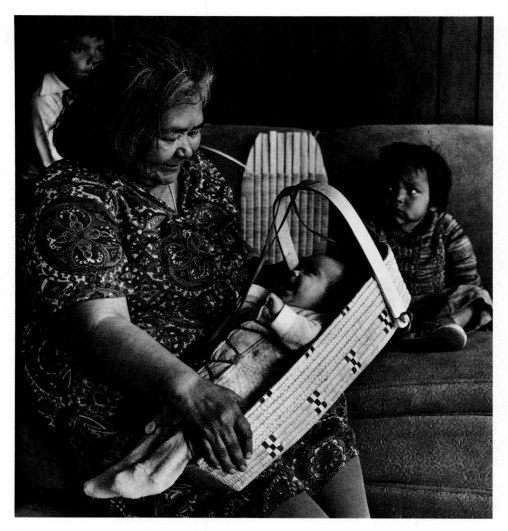

Catherine Pascal, Mount Currie

"I made the basket. It is for the baby.

"The white straw is made from red canary grass. We pick it along the highway up the valley before it blooms. After it blooms, it's no good. Then we steam it or put it in boiling water and leave it on the line for a whole week. Then we cut it up all in bundles and put it away till we use it.

"The wild cherry bark is scarce around here. I need to hire a car to get it. If we want to dye it we just dig a deep hole over there. The water comes up and it is real rusty and we bury the bark in it for a whole year. Then it gets black."

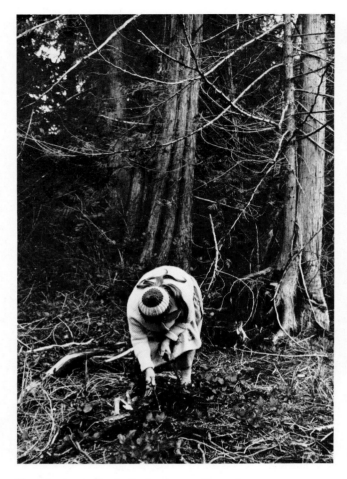

Mary Jackson, Sechelt, digging cedar roots

"It gets harder every year to find good roots. Too much underbrush; the roots don't grow straight. I have to go far away to find some."

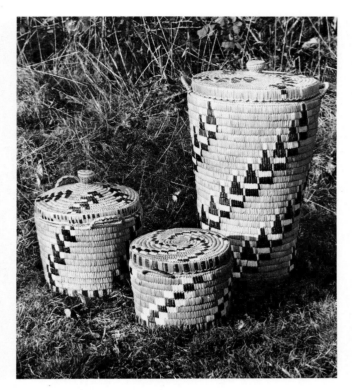

Baskets by Mary Jackson
Courtesy of Dr. and Mrs. Walter Burtnick, Sechelt

"The colored designs on the baskets are wild cherry bark and white straw. To make the cherry bark get black we have to soak it in water with some iron for a long time."

110

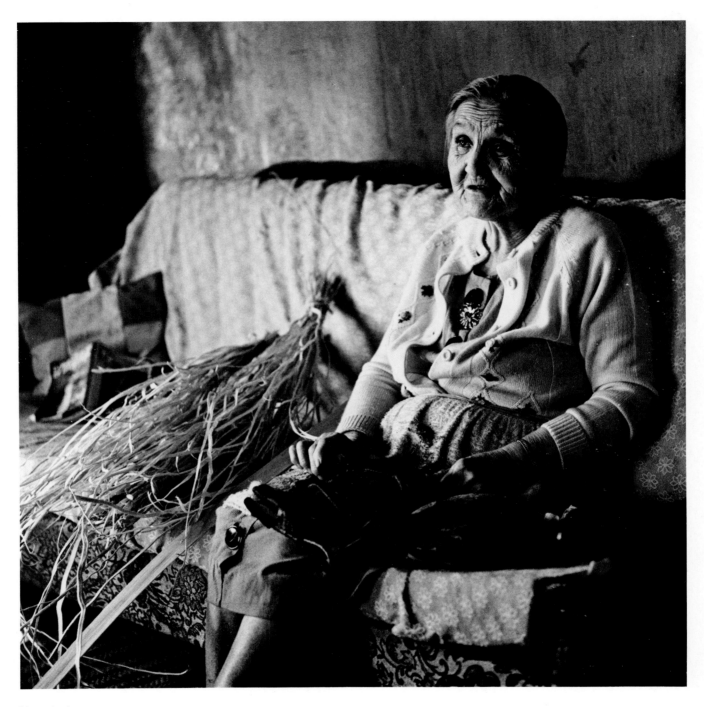

Mary Jackson

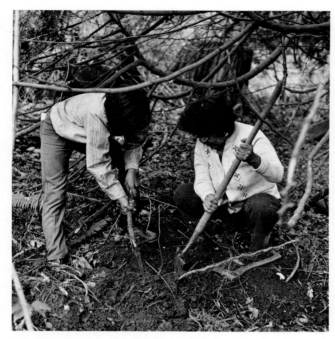

Maggie and Vernon Jack, Penelakut Reserve on Tussie Road, near Chemainus, digging cedar roots

"I always tell the tree I'll be back for some more."

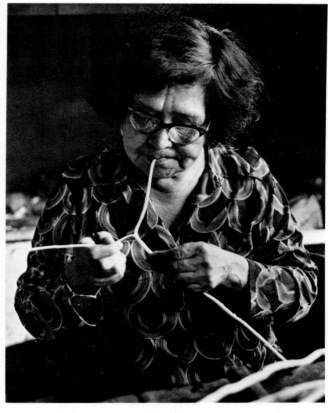

Maggie Jack, splitting cedar roots

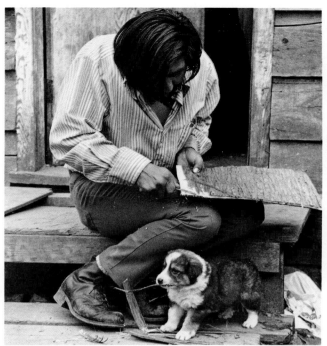

Vernon Jack

Vernon Jack's canoe bailer

"You've got to work on the barks right away—when they are still wet."

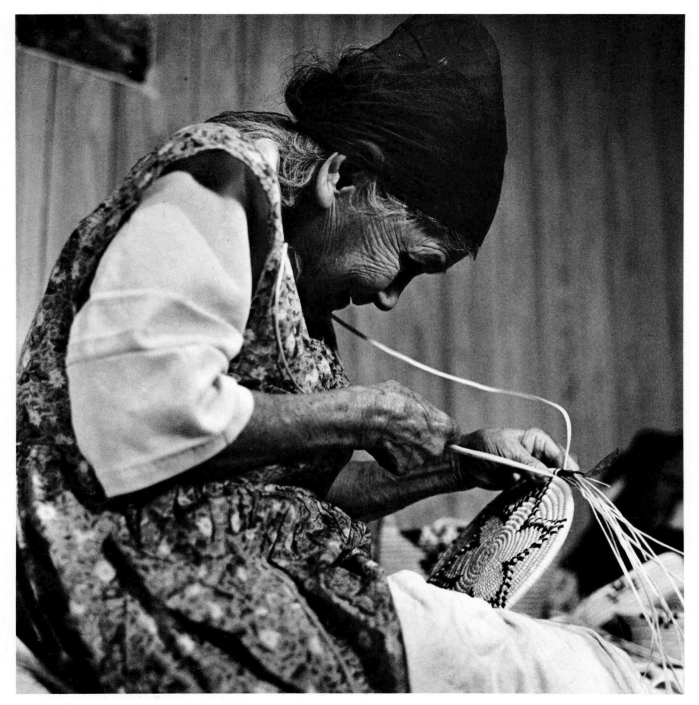

Christine Bobb, 86 years old, Boothroyd Reserve

"I go by myself. I dig my own roots."

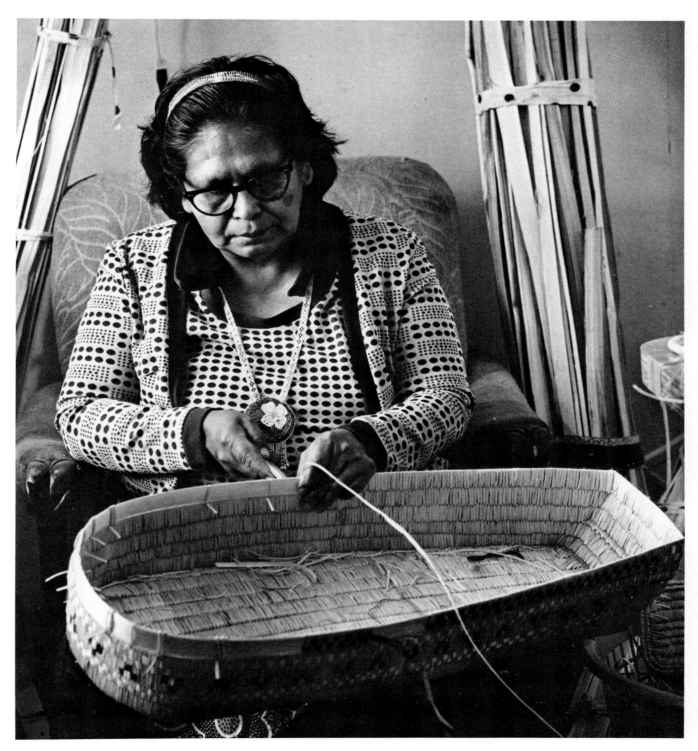

Elsie Charlie, Yale, finishing off a baby basket

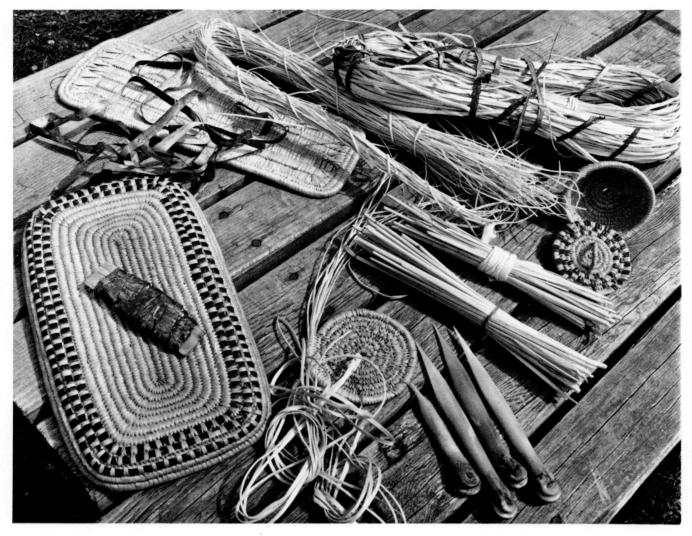

Elsie Charlie's materials and tools— deerbone awls, cedar
roots, white straw, and wild cherry bark

"The small awl was my mother's; it used to take her a week or
two to shape and sharpen one of them."

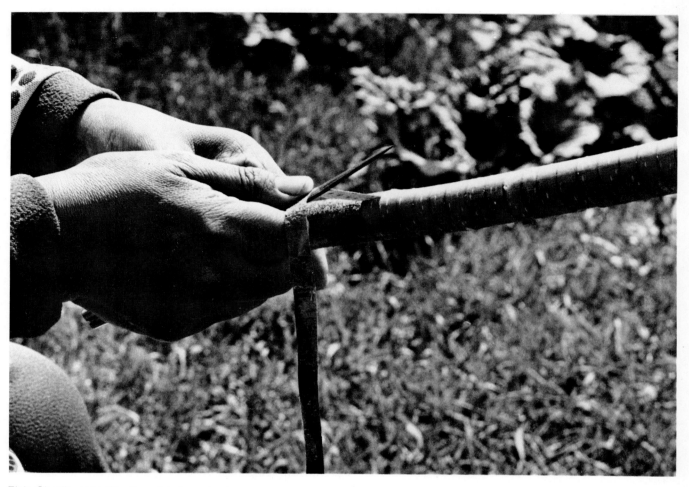

Elsie Charlie, stripping the wild cherry bark

"My mother used to tell the tree she would not waste any of it."

OKANAGAN AND
CARRIER BEAD AND
LEATHER WORKERS,
CARRIER BIRCH
BASKET MAKERS

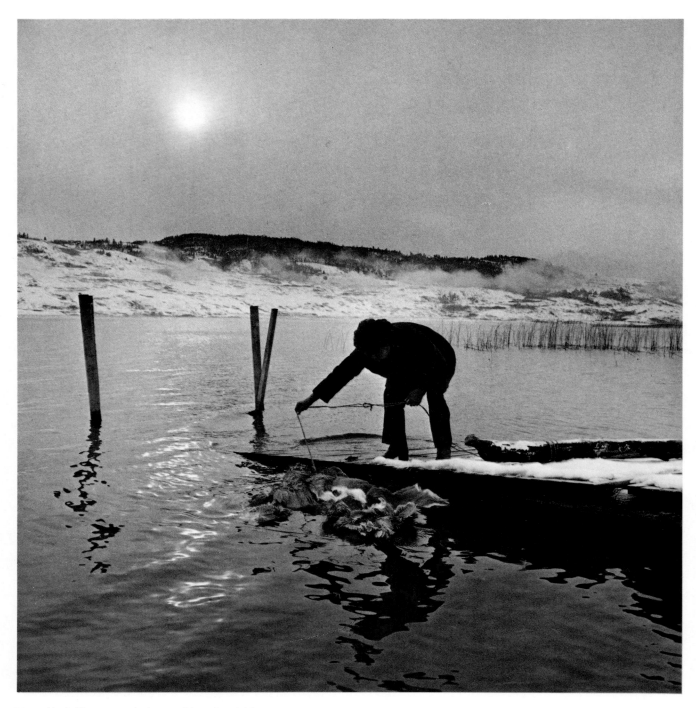

Mary Abel, Okanagan Lake, soaking deer hides

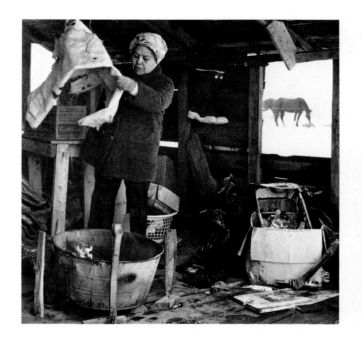
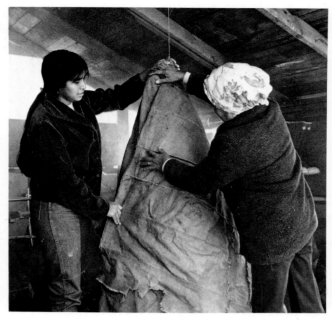
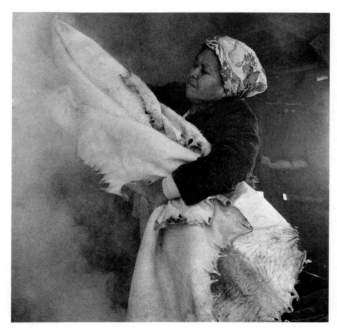
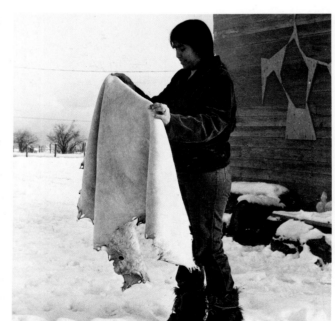

Mary Abel and her daughter, Hilda Belanger, tanning deer hides with rotted pine wood

Stony Creek Reserve, near Vanderhoof

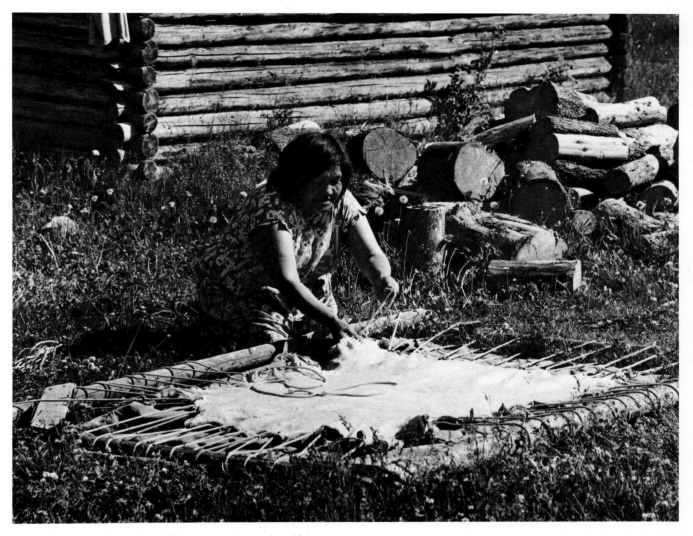

Sophie Thomas, Stony Creek Reserve, roping a deer hide to the stretcher.

"It is a lot of work to finish a hide. You soak it a week in water, then stretch it. When it is half dry, you scrape it with the small scraper to take out the flesh and hair. Then you wash it in soap water two or three days and wring it again. Stretch it and soften it both sides with the big tool. Then you sew it together to make it a pipe for the smoke to stay in it. I use poplar wood to get a bright yellow, spruce for darker brown, and jack pine for light gold. But the wood has to be rotted. You have to fast when you smoke it, or the smoke will turn black."

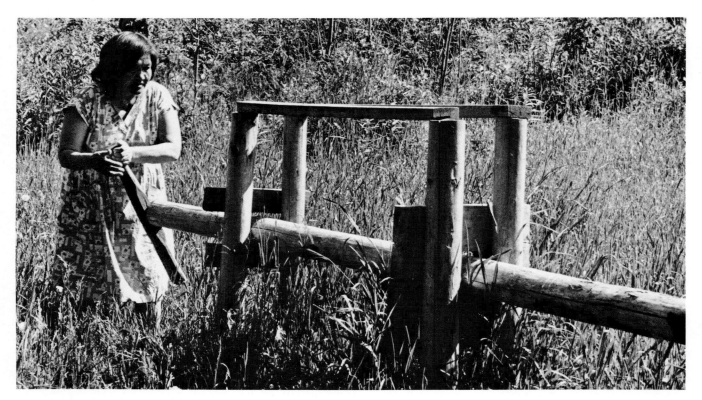

Sophie Thomas, using a hide wringer made by her husband,
Morris

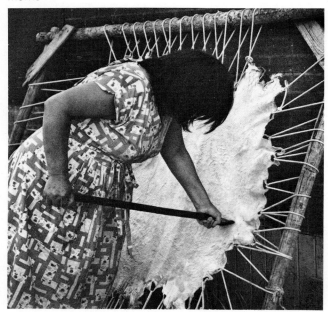

Sophie Thomas, scraping the stretched hide

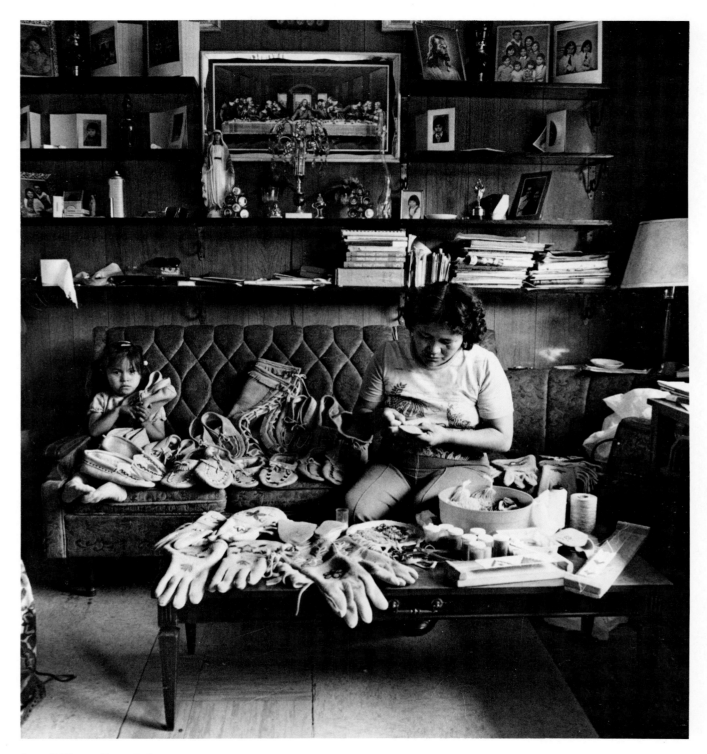

Anne Williams, Burns Lake

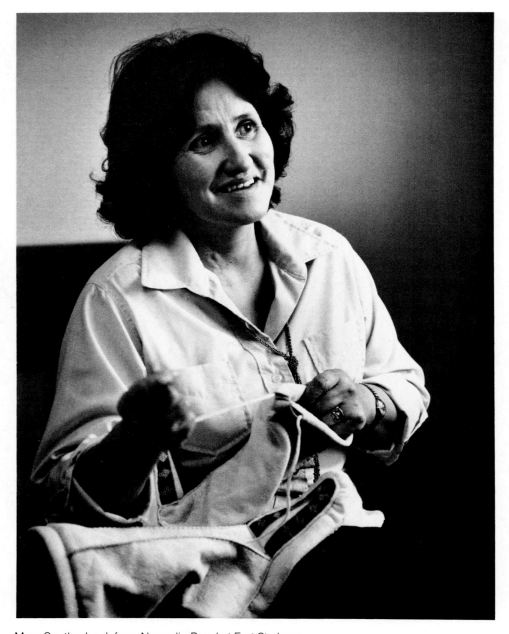

Mary Southerland, from Necoslie Band at Fort St. James,
now in Sardis

"I'm just glad my mother made me keep at my beadwork when I
was a kid; otherwise, I would not be able to do this today.

"I learned the designs from my mother. I just try to improve
on them."

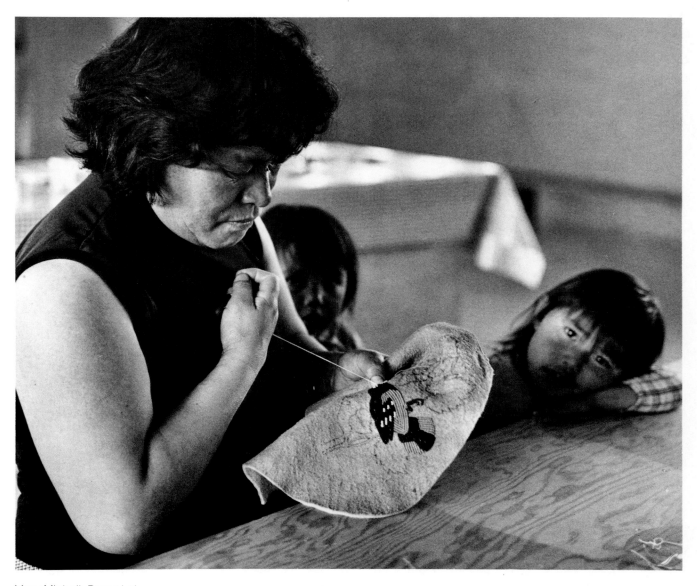

Mary Michell, Burns Lake

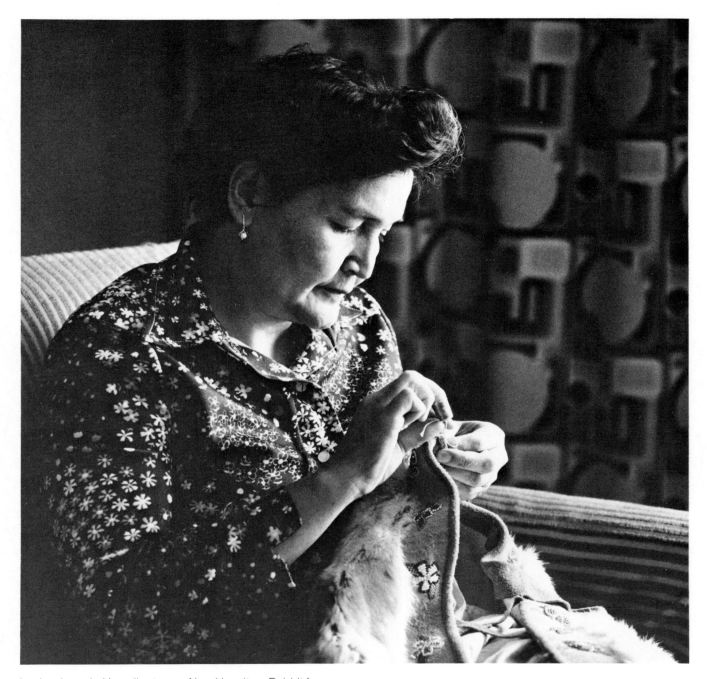

Louise Joseph, Hagwilget, near New Hazelton. Rabbit fur
and beads

"I make something for one of my girls and all the others like to
get one, too; but this cape is for Bertha's wedding."

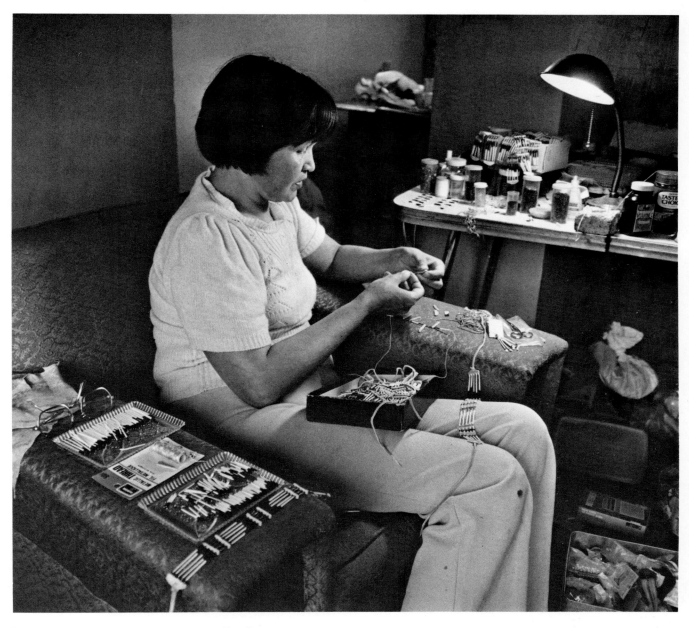

Bernie McQuary, Nautley Reserve, near Fort Fraser

"I often wake up early in the morning with a new idea for a
necklace or some earrings, and I try it right away."

Birches

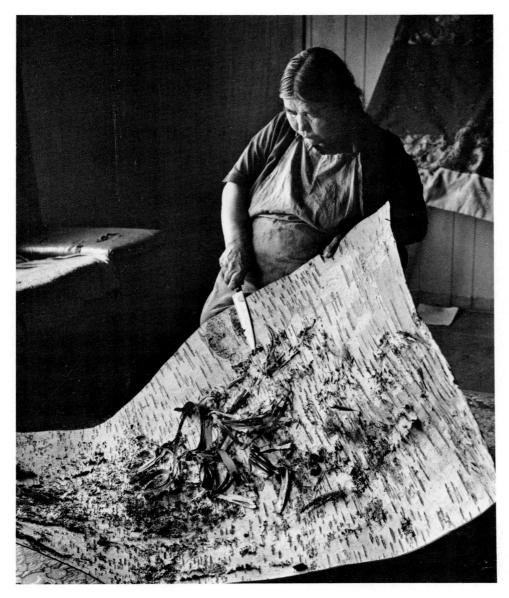
Jenny Naziel, Moricetown, scraping birch bark to make a
basket

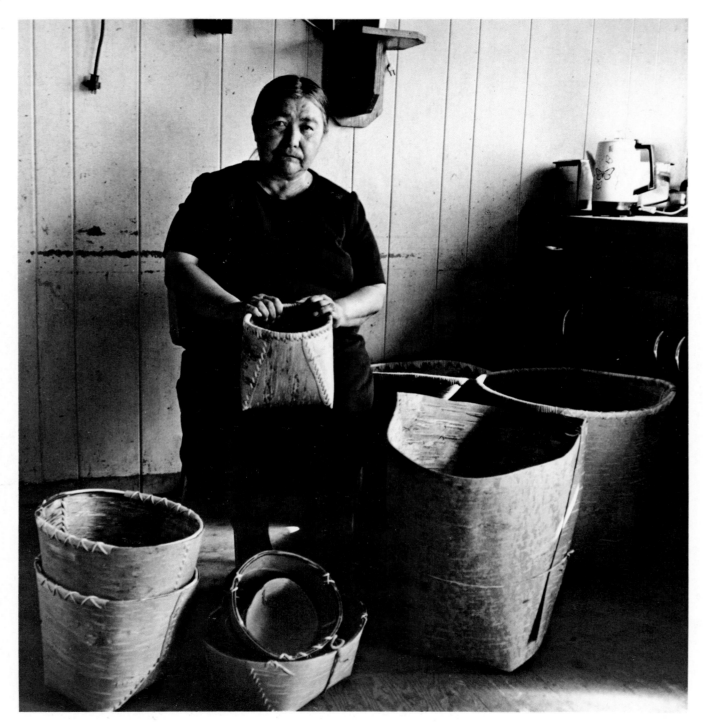

Jennie Naziel with her baskets

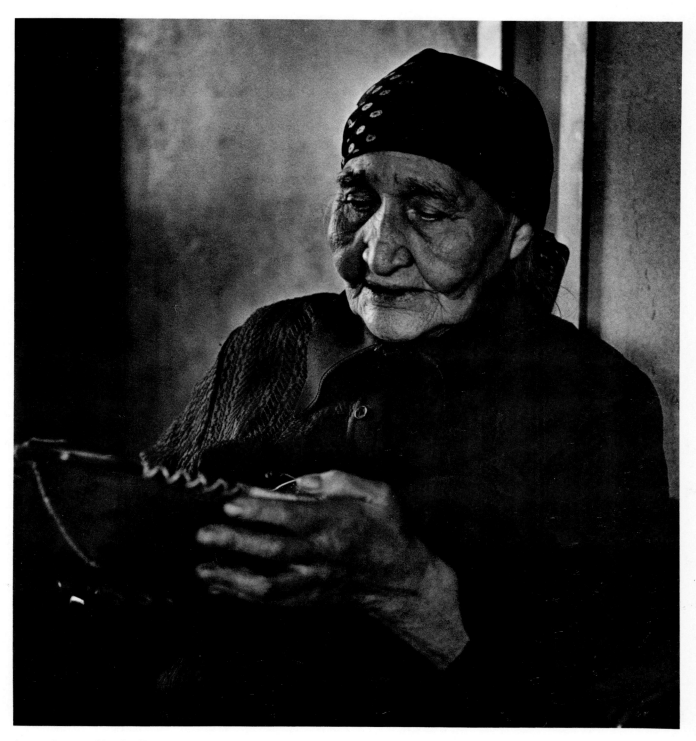

Agnes George, Nautley Reserve

GITKSAN CARVERS
AND
BLANKET MAKERS

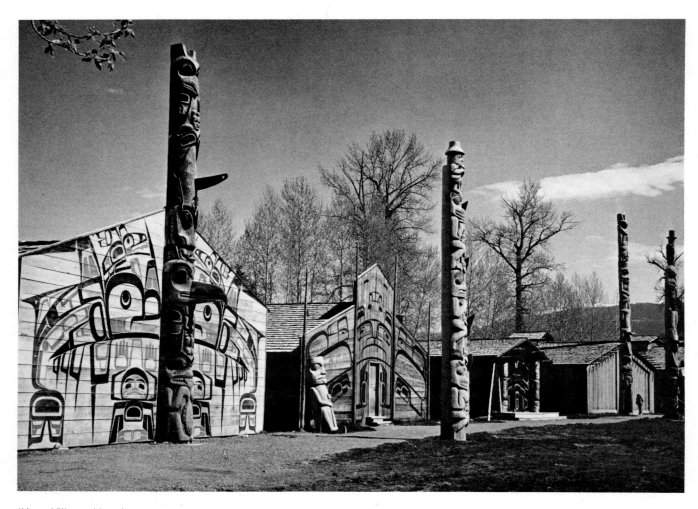

'Ksan Village, Hazelton

"Many of us were working towards the realization of 'Ksan, but Polly Sargent was the force of our committee. Her faith in my people and her dedication made 'Ksan become a reality. The village was officially opened to the public in 1969. It is similar to the old Gitksan village that was there long ago. But it is not only a historic site. It is also used for feasts and dances, and it houses a learning centre and provides working space for our northwest coast Indian artists."

Doreen Jensen

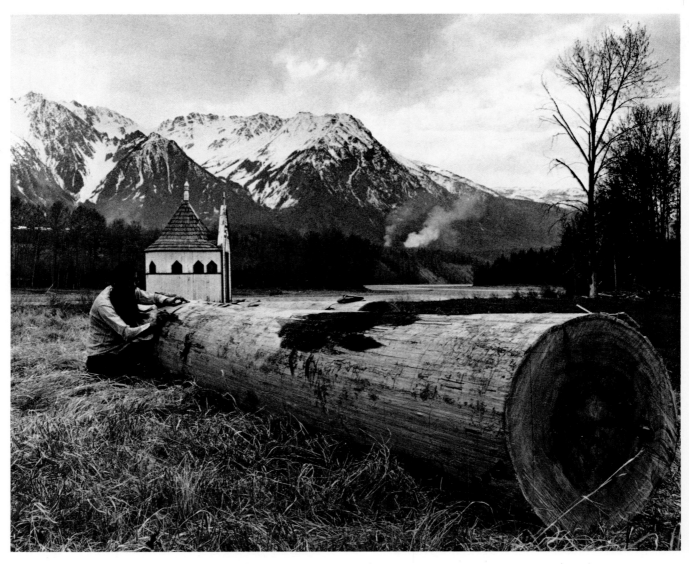

Vernon Stephens, starting to make a canoe out of a red
cedar log at the 'Ksan grounds

Vernon Stephens with adze

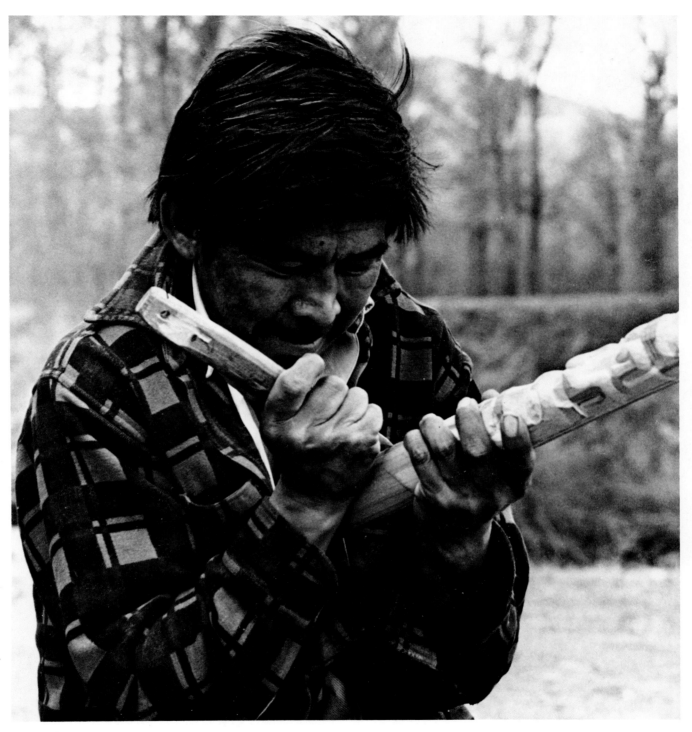

Herbert Green
Talking Stick, yellow cedar

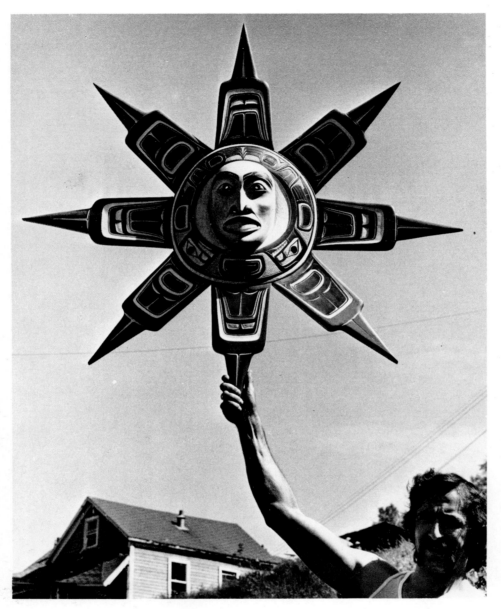

Art Sterritt
Sun mask, alder, made for the 'Ksan Dancers

140

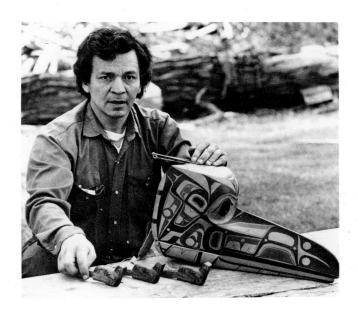

Earl Muldoe
Raven Transformation mask
Outer mask, red cedar; inner mask, birch; three Raven
Heads for string control

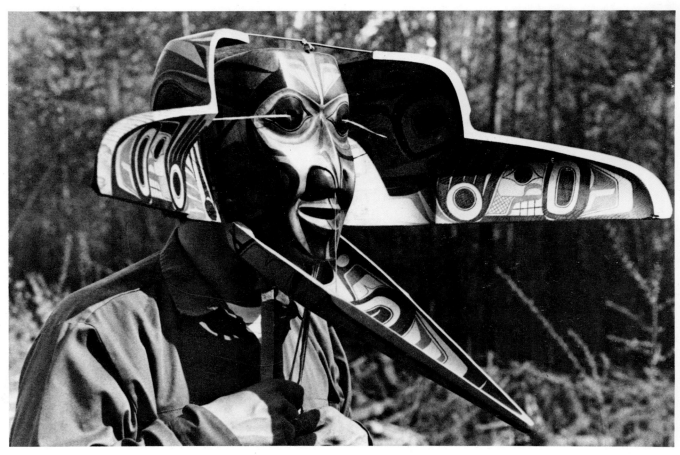

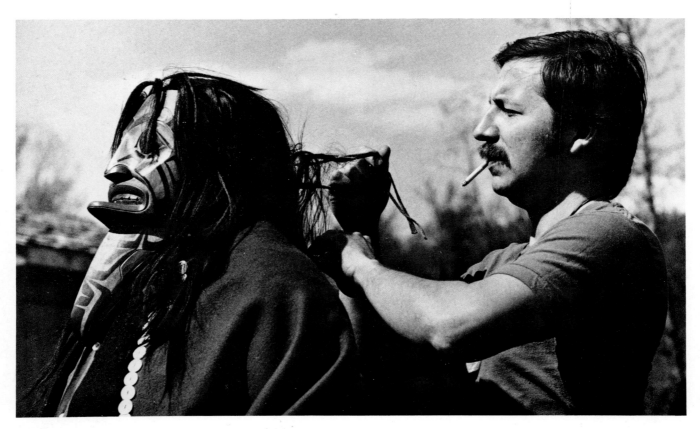

Robert Jackson
Weget transforming from Raven to Human. The beak
representing the beard stays as a beak.
Gitksan legend

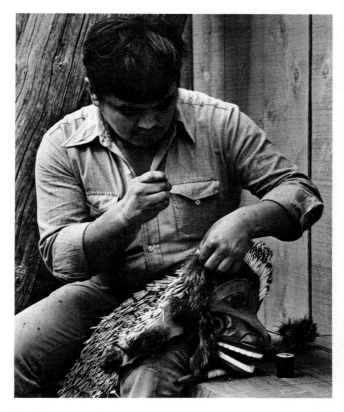 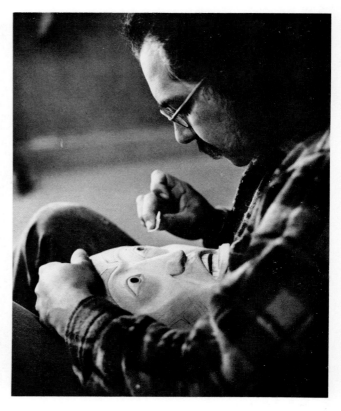

Ron Sebastian, Carrier from Hagwilget, works in the Gitksan tradition. Ronnie is sewing quills onto the birch Porcupine mask that he is making for the 'Ksan Dancers.

Glen Rabena, from Yakima Reservation, Washington, carves in the Gitksan style. Mask of a Woman, birch.

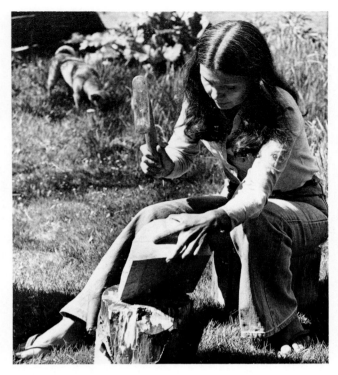

Doreen Jensen, using an elbow adze to make a mask

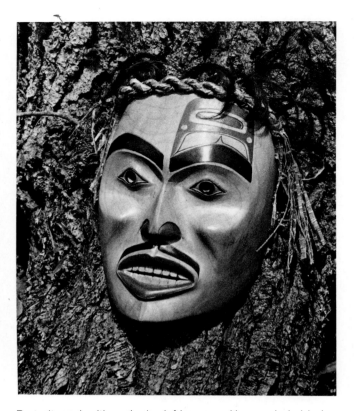

Portrait mask with cedar bark fringes and human hair, birch, by Doreen Jensen

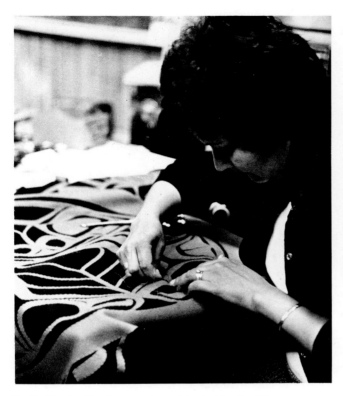

Sadie Harris, Kispiox, sewing a blanket for the 'Ksan Dancers

"We use the blankets in our ceremonial functions or dances. They are all hand sewn, every button."

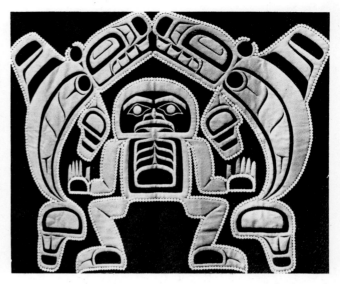

Double Killer Whale blanket sewn by Sadie Harris from a design by her husband, Walter

"The Double Killer Whale is Walter's family crest."

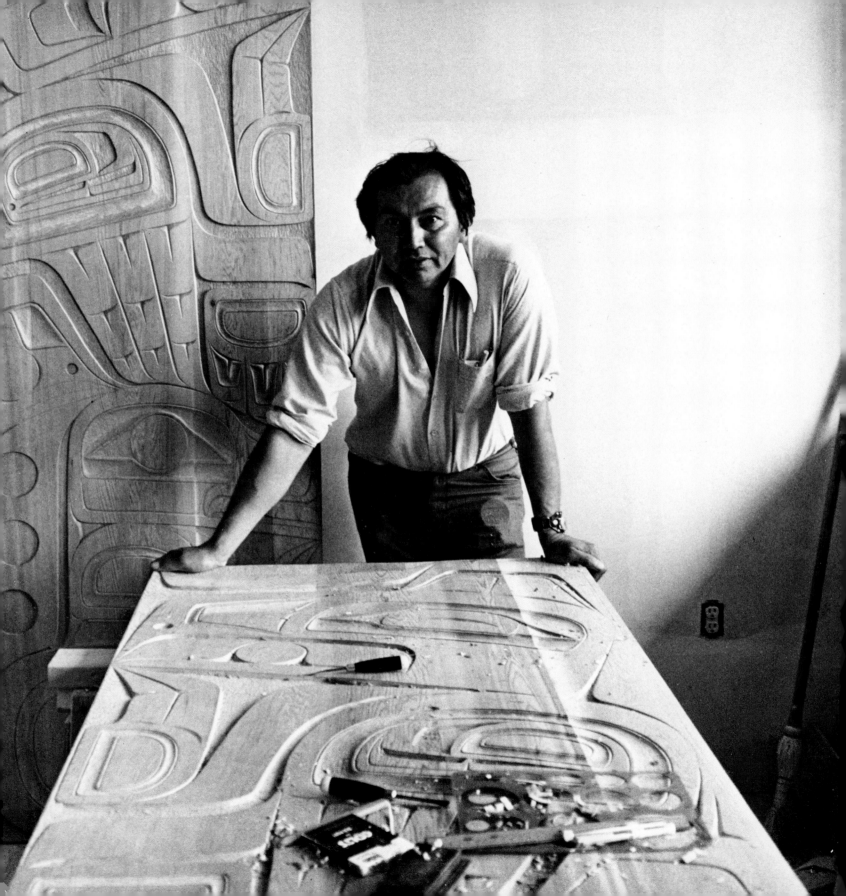

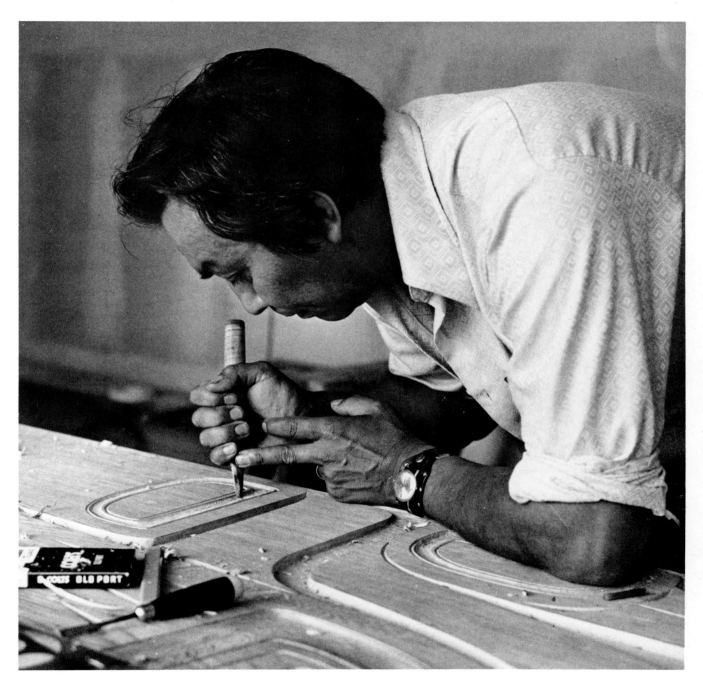

Walter Harris, Kispiox, with doors carved for the Royal
Centre, Vancouver

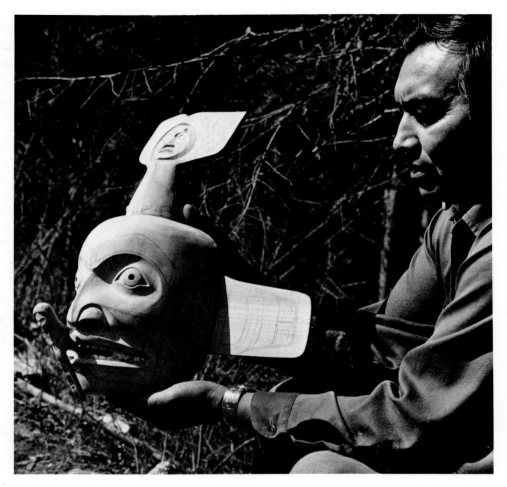

Mask, Salmon in Human Form, alder with abalone inlay,
by Walter Harris

"Weget changed into a salmon so he could steal the bees off the hooks. He was hooked on the jaw, and when the kids felt they caught something heavy on the line, they all got together and pulled on it. They pulled his jaw right out. So he carved himself a wooden jaw to replace it. This is why the mask has a moveable jaw. The little figure represents the hook."

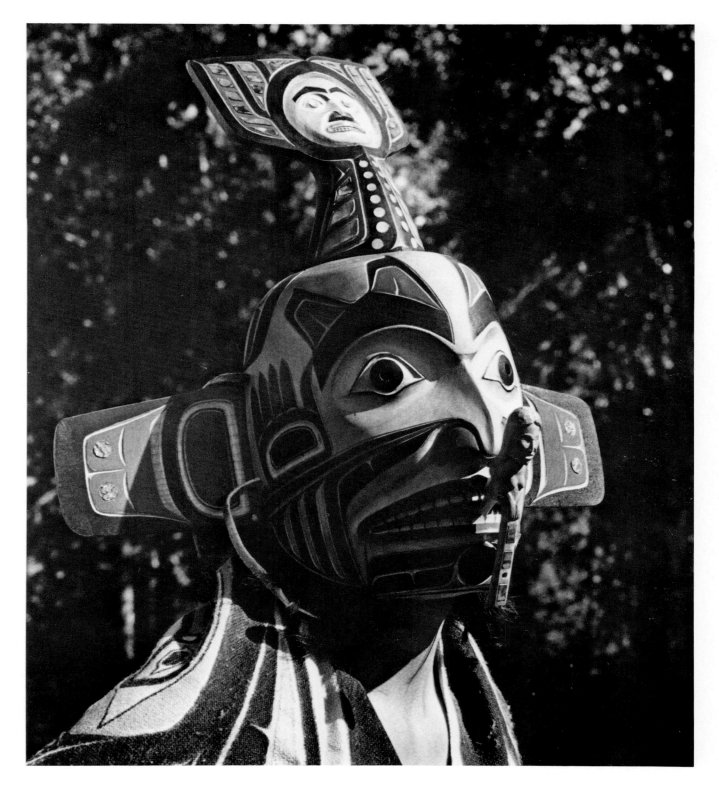

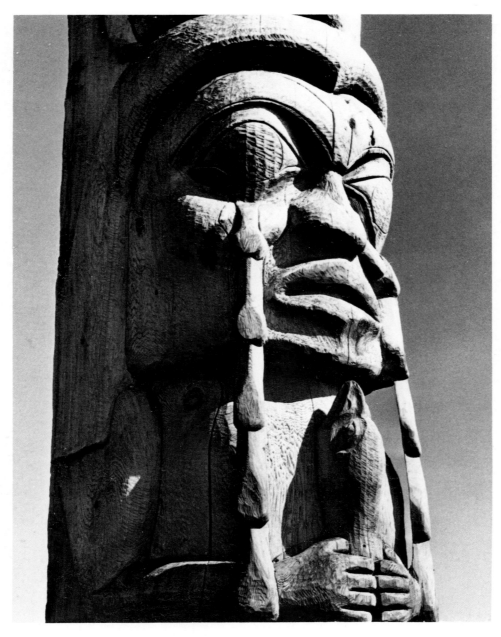

Crying Woman with Grouse, detail of the 'Kilhast (One Fireweed) Pole at Kispiox, carved by 'Ksan carvers

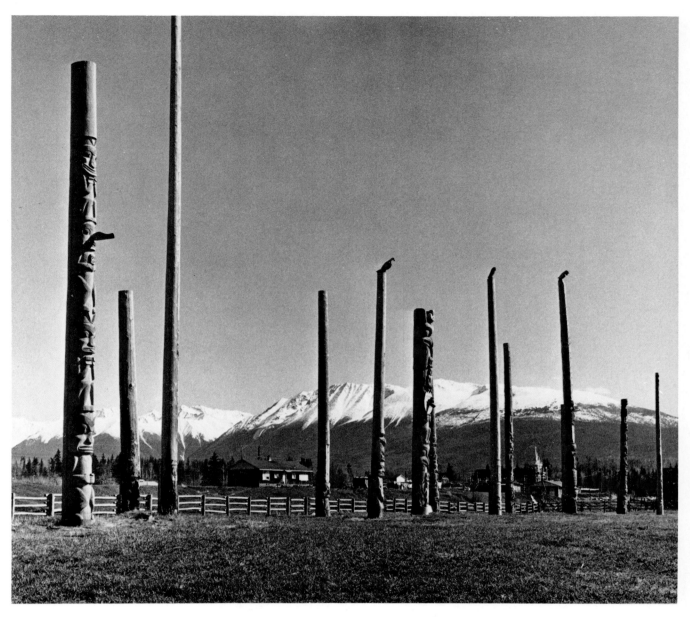

Poles at Kispiox

THE NASS RIVER,
STIKINE RIVER,
AND PRINCE RUPERT
CARVERS

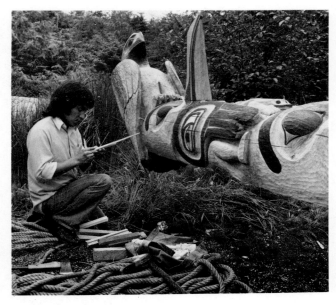

Norman Tait, Nishga from Kincolith, Nass River, now in Vancouver
The pole, made for the Port Edward community and representing all its family crests, was carved by Norman with the help of his father, Josiah Tait.

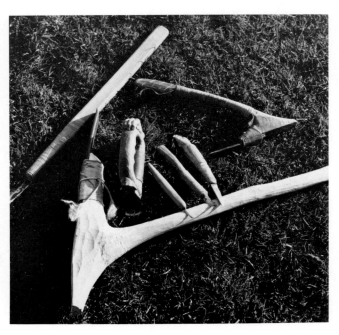

Carving tools by Norman Tait

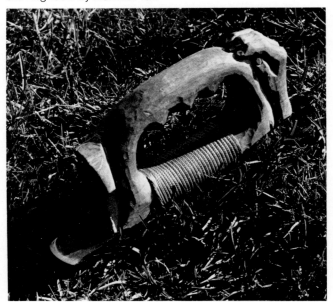

"D" adze by Norman Tait

154

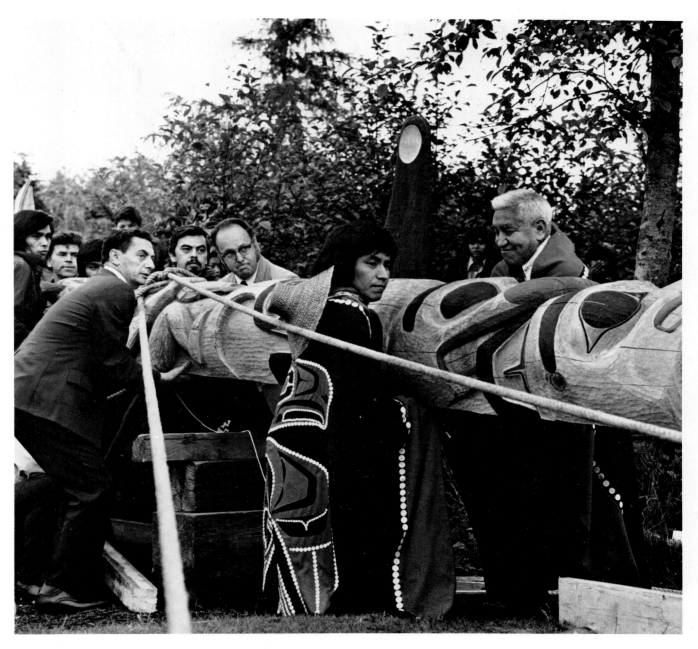

Pole-raising ceremony, Port Edward, 1973
Norman and Josiah Tait are pushing the pole off the ground.
When it is lifted up high enough, the ropes will take over.

Wayne Peterson, Haida carver from Port Edward, bringing
home a piece of alder to carve a mask

Don Yeomans, Haida carver, Prince Rupert

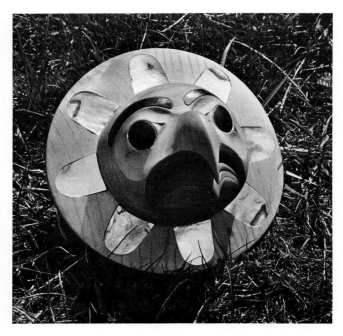

Eagle frontlet, alder with abalone inlay, by Dale Campbell

Dale Campbell, Tahltan from Telegraph Creek, Stikine River, now in Prince Rupert

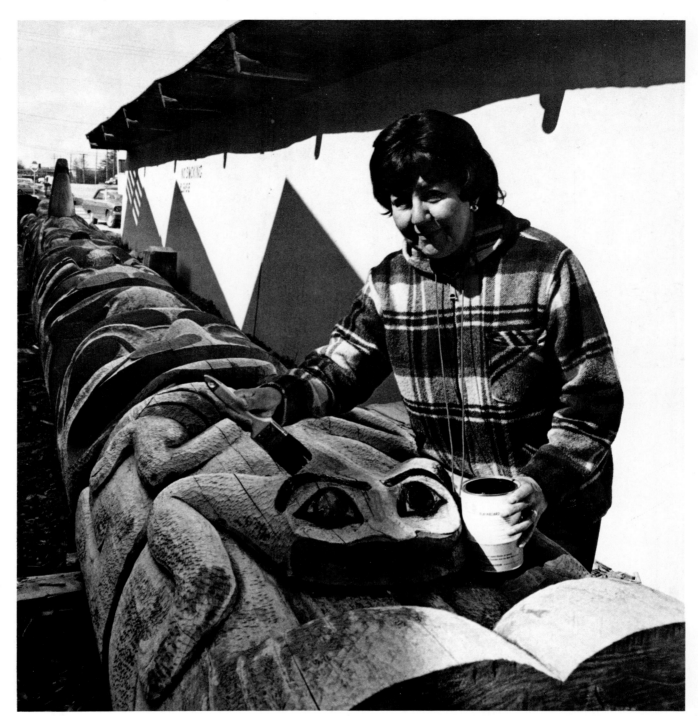

Freda Diesing, Prince Rupert, Haida artist and carver in the northwest coast Indian tradition. The pole was carved by Freda and Josiah Tait.

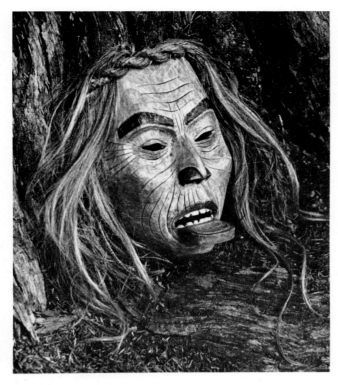

Old Woman with the Labret, alder, by Freda Diesing

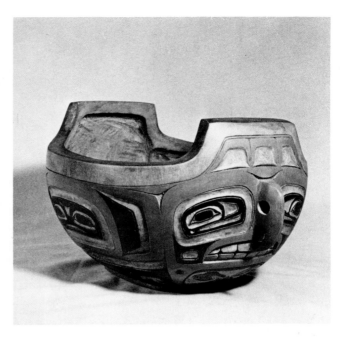

Hawk bowl, alder, by Freda Diesing

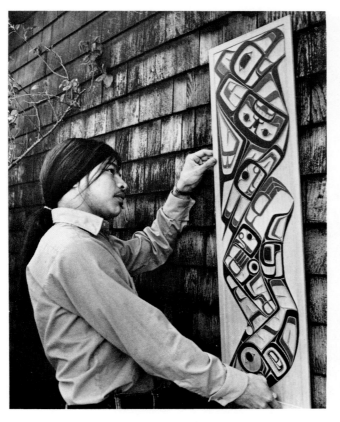

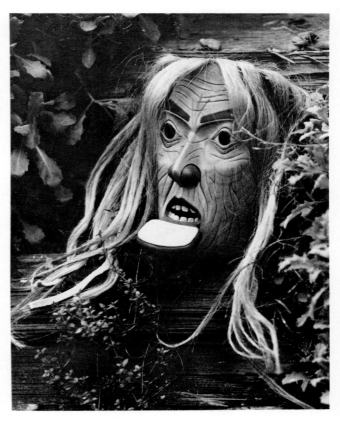

Glen Wood, Gitksan carver from Kitwancool, now in Prince Rupert. The carved panel shows the Thunderbird carrying the Killer Whale off; a man rides on the back of the whale behind the fin.

Old Woman with Labret, unfinished, by Glen Wood

"I am proud of every carving—it is the best I can do at this time with what I know.

"For new ideas we Rupert carvers like to socialize. We just go around spying on each other. Freda's place is the best one to go to. I go spy on her. It is not deliberate—we really just visit one another."

Dempsey Bob, Tahltan-Tlingit artist from Telegraph Creek,
Stikine River, now in Prince Rupert

"I like wood; I like to feel it.

"Each different wood has its own purpose. I make masks out of alder; it is light and hard. We also use it for our bowls and spoons because it has no taste. Yellow cedar has a strong taste when it gets wet. Red cedar we use for our canoes and houses and large totem poles. Birch is good for rattles; it is harder and gives a better sound.

"We've got an idea and know what we're going to make before we go and get the tree. Mostly we carve alder—there is a lot of it in our area. We have no birch, but we sometimes use it and go inland to get it."

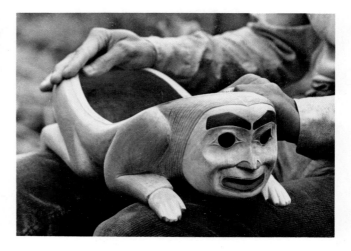

Human bowl, birch, by Dempsey Bob

"It doesn't worry me that things of the past have disappeared, because we are here and we are making new things."

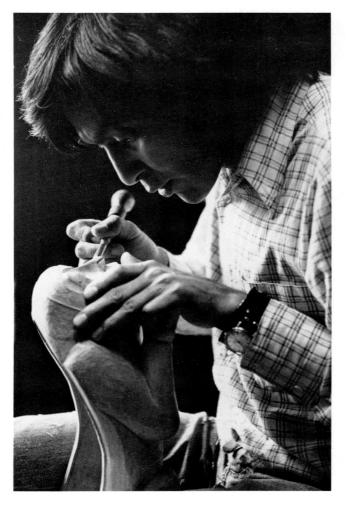

Dempsey Bob

"I like the human figure."